Hope *and* Heroes

PORTRAITS OF INTEGRITY

Hope *and* Heroes

PORTRAITS OF INTEGRITY

Best wishes!

Photographs by
Barry Shainbaum

Co-authored by
Madelaine Palko *and* Shannon Fitzgerald

Foreword by
Uri Geller

London Street Press
Toronto, Canada 2001

Published in 2001 by London Street Press, 130 Spadina Avenue, Suite 602 Toronto, ON M5V 2L4

Ordering information:
Distributed in Canada by Hushion House Publishing Limited,
36 Northline Road Toronto, Ontario Canada M4B 3E2
Phone (416) 285-6100, Fax (416) 285-1777

Distributed in the United States by General Distribution Services, Buffalo, NY.

National Library of Canada Cataloguing in Publication Data

Shainbaum, Barry, 1952-
 Hope and heroes : portraits of integrity

ISBN 0-9688645-0-3

1. Portrait photography—Canada. 2. Canada—Biography.
3. Shainbaum, Barry, 1952– I. Palko, Madelaine, 1955– II. Fitzgerald, Shannon IV. Title.

TR680.S45 2001 779'.2 C2001-902321-9

Cover photo is of Martin Sheen

Book designer – Karen Petherick
Editor – Debbie Koenig
Proofreader – Bill Belfontaine
Design for Hushion House Publishing Ltd., catalogue – Megan Barnes
Printed and bound in Canada

The following information was taken from the Internet sites listed:
Gallop quote for Billy Graham reference: www.gallup.com/poll/releases/pr991213.asp
Mandela references 2nd paragraph: www.anc.org.za/people.mandela.html
Reference for quote under photo: Nelson Mandela, Globe and Mail, May 5, 2000

DEDICATION

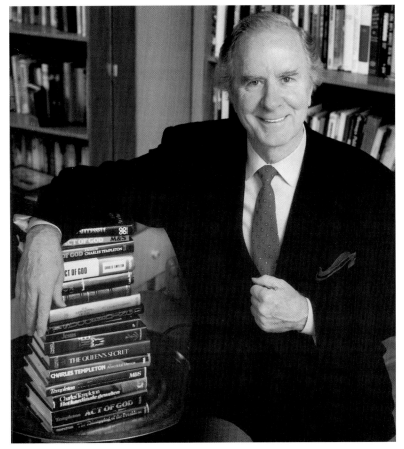

Photo by Barry Shainbaum, 1992

Dedicated to Charles Templeton (1915 – 2001)
who inspired me to create this book.

Charles was a multi-talented man whose careers included being an
author, editor, evangelist, broadcaster, playwright, and inventor.

He is sorely missed by those who knew and loved him.

ACKNOWLEDGEMENTS

thank the love and support of my late parents Hy and Ada Shainbaum
and
the late Margie Reese and Yogi Narayana.

A heartfelt "Thank You" to the 47 participants in Hope and Heroes.
To all of representatives of the above, thank you for your assistance.

Thanks to Shannon Fitzgerald who approached participants in this book.
Thanks to Madelaine Palko and Shannon Fitzgerald for writing the biographies.
Thanks to David Schatzky for creating the majority of the interview questions. David was a
CBC Radio broadcaster in Canada for many years. He is a practicing psychotherapist in Toronto.
Thanks to Steve Thomson who first assisted me in getting this book off the ground.

A great big "Thank You" to Uri Geller for his foreword;
to everyone at Hushion House Publishing Ltd., for their support;
to Karen Petherick for her inspired book design;
to Michael Petherick for his artistic assistance;
to Debbie Koenig for her dedicated editing;
to Bill Belfontaine for his proof-reading and advice;
to Lori Rennie at Transcontinental Printing;
to Brenna Hutchings and Bonnie Francis for transcribing the interviews.
to Rose Scheler for her expert assistance in production of the book;
to Linda Fitzgerald for her writing assistance;
to The Empire Club of Canada for their supplying of a draft of Billy Graham's speech;
and the following supporters:
Michael Collopy
Tom Corwin
Michael Levine
David Titcomb
Vistek Ltd.
Fred Deeley Imports
Marriott, Manhattan Beach, California
Marriott, Vancouver Airport
Hilton, Vancouver Airport
Acqua Hotel, Mill Valley, California
Collingwood Scenic Caves

A heartfelt "Thank you" to BGM Imaging who provided high-quality
developing and printing of the photographs in this book.
www.bgmimaging.com

TABLE OF CONTENTS

FOREWORD

There exists a well-known and oft-recounted adage that a picture tells a thousand words. Barry Shainbaum, whose friendship I have the immense pleasure of sharing through his work, is undoubtedly testimony to this proverb. Rarely have I come across an individual whose fruits of his labour portray such incredible depth and meaningfulness.

Barry's portrait photographs have captured, with awe-inspiring vividness, the atmosphere and aura not only of the person's physical being and features, but of their hidden life story, invisible to the naked eye, revealed partially in this book. There is unquestionably something almost paranormally special about *Hope and Heroes: Portraits of Integrity*, and I feel the best way of summing up this sentiment is to simply say that Barry has managed to depict the very being of amazingly talented and unique individuals who have achieved major inroads in their field, whether it be charity, literary, therapy, politics, science, business or entertainment. There is a uniting thread which links all the people in this book, and it is one which recognizes each and every person's attainment of an heroic commitment to help others, to help heal the world. Barry Shainbaum has inspirationally encapsulated the spellbinding honesty which radiates from within his subjects.

The title of his book started me thinking about my own understanding of the word 'hero'. I am certain that a great many will see eye to eye when I reveal that for me, a hero is somebody who has risked his own life to save another's. Heroes come from all walks of life, they are not all famous and they are not all adult – heroes are also children who have rescued their parents, friends and pet animals. Heroes are people who have fought for their country and were tragically all too often killed, heroes are parents who bring up and care for their children, heroes are people who do their bit for humanity, heroes are each and everyone of us who aim to do their best. My personal heroes are people such as the astronaut, Captain Edgar Mitchell, who was the sixth man to walk on the Moon and those who have, like him, stepped into their unknowns.

Before the creation of television, which brings us movies, documentaries, around-the-clock information and news, the telex and fax machines and today the Internet, we captured powerful moments in history through photographs. The era of communication has sadly eroded, in part, the importance and significance of the photograph, which is why it is so uplifting to see the works of people such as Barry.

A *live* picture is capable of capturing with extraordinary truthfulness and honesty an infinite range of emotions: happiness, joy, delight, ecstasy, sadness, anxiety, grief, devastation and anguish. We are able to view forever the wonderful moment of a woman conceiving a baby, the mystery of the universe and stars, the fragility of Earth.

The other concept which is evoked in Barry's book is that of hope, which lies at the very essence of our being. Hope ensures the survival of our planet, our lives and humanity. We need it to continue to exist, from comforting dying children to the need to preserve the raw beauty of our planet, from ecological endurance to conquer ravaging diseases, natural disasters, political upheaval and wars.

Barry Shainbaum's astonishing skill and ability are evident in this book. The positive and rousing words of the people he has chosen to photograph and interview, should be read carefully and diligently. They can open up your imagination and guide you through their own achievements of heroism.

I was most honoured to be approached by Barry, although I do not see myself as a hero at all, but rather as a catalyst, a trigger and an enabler of others to tap into their inner minds and harness the power to make their lives better.

As a motivational speaker, I was astounded by Barry's perseverance and complete dedication to his work. Every time a door was slammed in his face, he just reopened it and walked right through. For this he is to be commended most soundly.

Barry is one of the greatest photographers alive today, an inspiration to all, and I so truly hope that this book will open up a pathway to eternal hope and heroism.

Uri Geller

INTRODUCTION

Hope and Heroes comes right from my heart. Although this project took three years to complete, the idea to create the book came to me as a result of a much longer journey, that of my own, to overcome adversity in my life. I was manic-depressive, or a bi-polar sufferer as it is known today. For eighteen years, and many more in therapy, I explored, prodded, and searched for the meaning of life.

I wondered for decades why I had to suffer such emotional turmoil. In 1988, the illness left me, never to return. It has been a long road back rebuilding my life and my photography career.

Many participants in *Hope and Heroes* had inspired me when I was incapable of functioning properly. I remember watching and listening to Dr. Robert Schuller on Sunday mornings and receiving the benefits of his sermons on *possibility thinking*. A voracious reader, I devoured the books on self-esteem by Dr. Nathaniel Branden and closely followed Dr. Wayne Dyer's search for what gave meaning to existence.

Hope and Heroes represents many parts of my life. I found the subjects from a wide range of places – the *New York Times,* to television programs like Ted Koppel's "Nightline" and "Oprah". I also found subjects for my book from reading about world events and from searching for heroes in my own country, Canada.

I couldn't help but be thrilled to realize how fortunate I was to be there with my tape recorder to conduct, first hand each breath-taking interview. Before you study the photos that I took, read carefully each subject's inspiring words.

I hope you will learn from their journeys. But more than that, look into your heart and visualize, then act on how you can make your own world, and that of your family, neighborhood, city and country, a better place to live.

Barry Shainbaum

DR. MAYA ANGELOU

Dr. Maya Angelou's life has presented her with challenges that she has needed great faith to overcome. When she was seven years old, Maya was raped by her mother's boyfriend. For the six years that followed, she did not speak. Maya explains that afterwards, "The man was killed, and I thought that my voice had killed him, because I had told his name, and he had been put in jail for one day and then released. Had I not told his name, I figured that he might still be alive. So I stopped speaking for many years, thinking that my voice might just go out and kill anybody, randomly…Eventually, poetry, music and love brought me out of it – my grandmother's love, my brother's and my uncle's love. Finally, when I was about thirteen, I tried to speak."

Finding her "voice" through love has led Maya Angelou through many creative transformations. Her diverse accomplishments include being the first black San Francisco streetcar conductor; a dancer and singer at a San Francisco cabaret called the Purple Onion, where she became publicly known as Maya – a name her brother had given her at seven years old; Alvin Ailey's dance partner; a dance teacher; a civil rights activist; a director and producer; a poet, playwright and writer.

Maya Angelou is brave and generous with what she has learned in her life. She has written many books, poems and scripts that explore her life experiences and the lessons that she has garnered.

Angelou believes that courage is the most important virtue. "Without courage, you can't practice any other virtues consistently. So, I would like to show courage and love. A well-known gospel song says, 'Lord, don't move your mountain, Just give me strength to climb it. You don't have to move that stumbling block, But lead me Lord around it.'"

Angelou believes that facing adversity and coming through it may be the most important thing that you can do. "Then you can see who you are, what you can live with, what you can overturn. Sometimes, a person who has gone through nothing painful and disturbing is so unprepared for life that you can't really make a friend of her or him, because you can't count on them. Whereas if you can survive hardship, you can sharpen yourself and make yourself strong. Then you become somebody to be relied upon."

Maya Angelou has this advice for people: "You may encounter many defeats, but do not be defeated. Dare to love and to live. If you live to be ninety, it's only about that long."

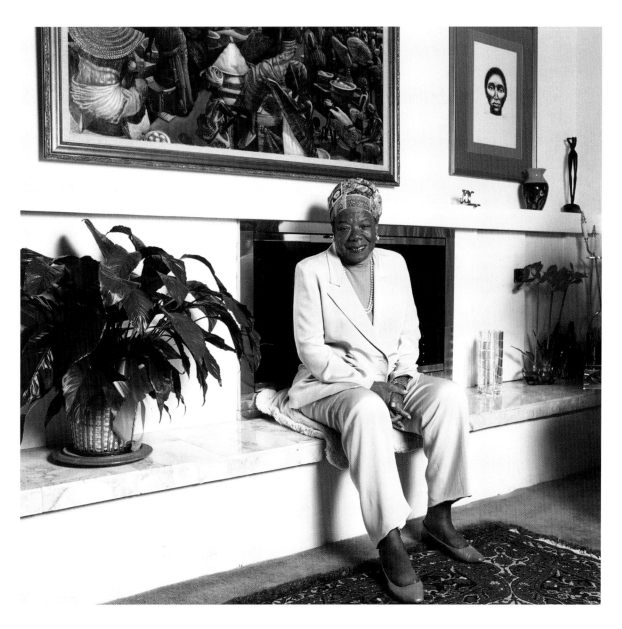

"I believe that integrity is fair play for everybody. If you put yourself first, and give to yourself, then you're more likely to be able to share with others, in dangerous times and pleasant times. All virtues and vices begin at home and spread abroad. If you're happy, you're likely to make someone else happy."

EDWARD ASNER

Most of us are familiar with Edward Asner the actor, who portrayed the affable, grumpy character, Lou Grant, in "The Mary Tyler Moore Show" (1970–1977), and a newspaper editor in the spin-off series "Lou Grant" (1977–1982). Less known to the general public is his social activism. Ed Asner explains his reason for pursuing these two directions in his life. "I went into acting to satisfy a need in my soul for safe adventure. (You can get tomatoes thrown at you, but it won't break any bones.) I think that my involvement in causes is similarly a form of safe adventure that also exercises my ego to do good."

In his office, Ed surrounds himself with shells, masks and other artifacts. He explains his interest in collecting. "I'm a very somber individual and these things put adventure into my life. I find the stories that fossils contain, from hundreds of millions of years ago, very exciting. I long to see a piece of history, even if it's petrified in stone. The fetishes and the masks all impart in me a basic emotion, the anthropological content of the people who made them."

Asner is actively involved in social causes that defend the rights of the underdog and the disempowered. He was a founding member of a group called Medical Aid for El Salvador; he was a board member of the Archbishop Romero Relief Fund, which helped the government of Nicaragua resist the Contras. In 1998, he visited Cuba with Mohammed Ali to help deliver medical supplies sent by aid organizations, to counter the effects of the American economic embargo on Cuba.

In the past, there have been repercussions for his involvement with Medical Aid for El Salvador. His left-of-center politics created a backlash from American politicians and commercial sponsors. Asner recounts: "I created quite a fire storm, which surprised the hell out of me. It was the beginning of the Reagan years, and right-wingers were everywhere in this country. Primarily because of my statements about medical aid, there were two separate attempts, led by congressmen, to boycott the "Lou Grant" show. Kimberly Clarke, Vidal Sassoon and Cadbury Chocolates all canceled their advertising spots. And according to various sources, William Paley, the head and owner of CBS, was so angry that he yanked the show off the air. I also received death threats."

Among the many people who have influenced Asner are his journalism coach; his brothers who gave him his macho side; his sister who gave him his intellectual and aesthetic side; his sophomore English teacher, who handed out poems for punishment; and ex-marines, who not only gave him a picture of war, but, a picture of the world.

When asked what his message is for people, Asner quoted his father: "If we can try to avoid being too circumspect and too rash, we'll live productive lives."

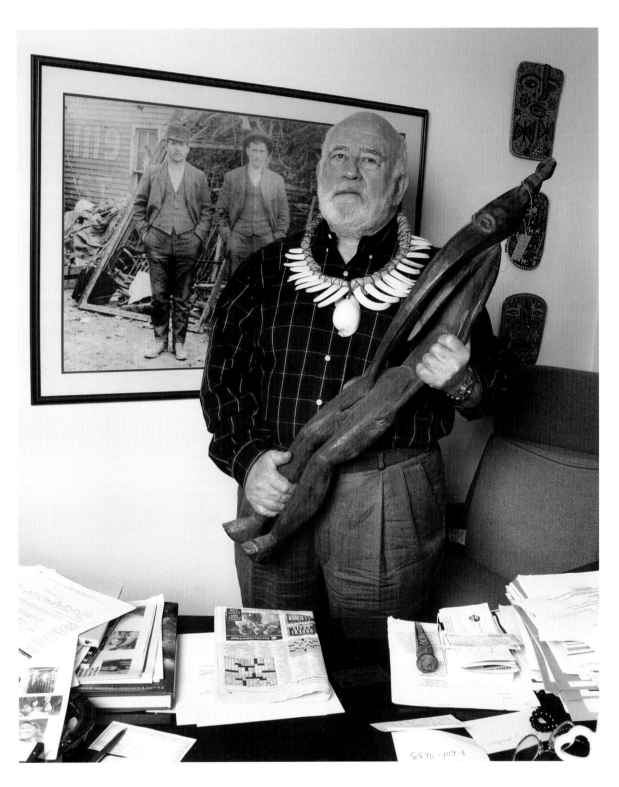

"Find something that you can work well at, and give it your best shot."

LUCAS BENITEZ

Lucas Benitez is a social activist. He works with his fellow farmworkers in Immokalee, Florida. "Us poor people, we're standing up and claiming just a part of what really belongs to us, because we work hard, and it's honest work. The only thing that we are asking for is better treatment.. We're all born with inalienable rights: the right to life, liberty and the pursuit of happiness. We, as immigrants in this country, and as Americans as well, are struggling for that."

When Lucas was eighteen, he and his brother attended a farmworkers' meeting, which got them involved in the organization they are building today, the Coalition of Immokalee Workers. "From that point on, we began taking a look at the different kinds of abuses that were occurring in our community. After analyzing the situation and doing several legal actions, we saw that the solution didn't lie in legal remedies. We had to start attacking the problem, not its branches but its very root. We realized that we, as workers, had to make the base of our organization stronger, that it wouldn't be someone from the outside struggling for us."

In 1995, more than 3,500 Immokalee farmworkers organized a week-long general work stoppage. This work action resulted in a wage increase for tomato pickers, the first that they had received in twenty years. The coalition was legally formalized and staff elected. Lucas, now co-director of the Coalition of Immokalee Workers, along with his fellow farmworkers, has exposed two slave labor operations and collected more than $100,000 in unpaid backwages. In 1999, a national youth leadership organization, the Do Something Foundation, and Rolling Stone Magazine, awarded Benitez and his coalition a $100,000 "Do Something BRICK Award," to support their work.

The coalition conducts training workshops to educate people about their labor rights, so they can, in turn, go out and train other co-workers. Recently, the Coalition of Immokalee Workers organized a 230-mile long march from Fort Myers to Orlando, Florida. They presented a petition of over 7,000 signatures to Governor Jeb Bush, asking him to use his influence to move industry leaders to engage in constructive dialogue with farmworkers about labor relations and working conditions in the fields.

Lucas acknowledges the influence his parents have had on his work. "They taught me how to work and to respect people for who they are, and not for what they possess.. If somebody mistreats you at work, you don't have to put up with it. You can answer them back and if they fire you, well, they're not going to be able to put their money to work."

"It doesn't matter if you're rich or poor, black or white, all of us one day will be leaving this world. The day that you leave, you don't take anything with you. I think that you can live with what's necessary, without having too much. I know that's difficult for some people, but the day that everybody can do that, that will be the day we change the world."

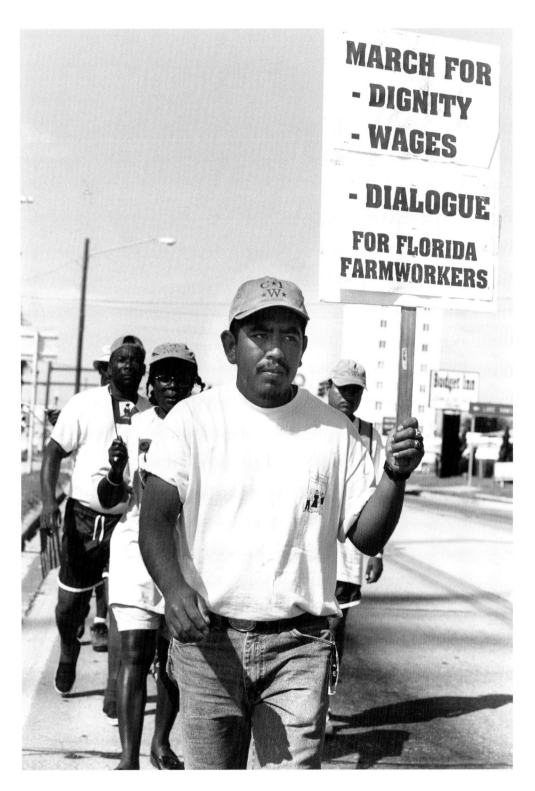

"Integrity is being sincere.
It's committing yourself to something, not just words, but through actions."

DR. NATHANIEL BRANDEN

Dr. Nathaniel Branden is a renowned psychotherapist, lecturer, consultant, writer and educator. He is a pioneer of the self-esteem movement, which attributes most psychological problems, at least in part, to people's lack of self-esteem, and teaches about how crucial self-esteem is to our well-being.

Born of Russian-Jewish immigrant parents, Nathaniel grew up in Toronto, Ontario. As a teenager, he was intrigued by what makes "so-called normal people behave quite crazily, not saying what they mean, not meaning what they say.. why one person is able to transcend certain adverse circumstances, whereas another person is drowned in them. I wanted to understand why people act the way they do."

Nathaniel Branden credits Ayn Rand, the celebrated novelist and philosopher, as a major influence in his life. "I met her just before I turned twenty. We had a very theatrical relationship which lasted over eighteen years." Branden has written extensively about his life experiences, including a book of memoirs published in 1999, about his relationship with Ayn Rand.

Branden's life work explores all aspects of the psychology of self-esteem. He has written many books, including: *The Six Pillars of Self-Esteem, Self-Esteem at Work: How Confident People Make Powerful Company* and *A Woman's Self-Esteem: Struggles and Triumphs in the Search for Identity*. His writings, public speaking, corporate consulting and private counseling sessions have helped millions of people worldwide to understand the true value of leadership, love, communication, responsibility and self-esteem.

When asked what he finds exciting about being alive, Branden responded, "Watching the circus that is always going on in my mind, and getting ideas from what I am reading, thinking or seeing.. Being with my wife with who I am very much in love and who is a great source of excitement and satisfaction, and being with our daughters and grandchildren."

Dr. Branden would like to be remembered as "a teacher of ethics and moral values, and as someone who gave people the courage to fight for their own lives." He believes we must be active in developing our resourcefulness, and tackling adversity head-on.

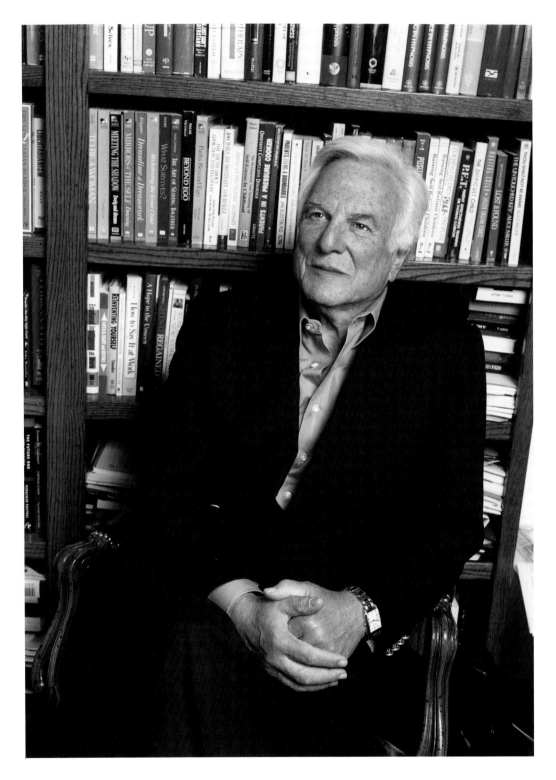

"Integrity is congruence between what we know, what we profess, and what we do.
When you see a lack of congruence, you're suspicious and distrustful.
You know something doesn't fit and you think, 'He doesn't walk his talk.'"

NANCY BRINKER

In 1980, Nancy Goodman Brinker's sister, Susan G. Komen, died of breast cancer. Before Susan died, Nancy vowed to her that she would help find a cure for this devastating disease that claims over 43,000 lives annually in the United States alone. She established the Susan G. Komen Breast Cancer Foundation in memory of her sister, with a mandate to "eradicate breast cancer as a life-threatening disease by advancing research, education, screening and treatment."

When asked what motivates her and what has helped her achieve her goal, Nancy said, "Fear. I think that fear of not doing what I promised my sister is sometimes as motivating as the wish to do it. I need to fulfill my commitments." Nancy also attributes her sense of determination to her parents. "As we were growing up, my mother used to tell us that it was our responsibility to fix what was wrong with the country, to not depend on other people. My father used to say, 'You can get anything with persistence and courage.'"

A few years after the Komen Foundation was established, Nancy Brinker was diagnosed with cancer, the same kind her sister had suffered through. "I was hysterical for the first few years. Like a lot of people, I thought, 'This is it.' I was sad for all kinds of reasons: I had just married; I had the Foundation to run; and I worried that I would never live out my promise to my sister. In addition to my devastation, I was dealing with the physical ordeals of the surgery and the side effects of chemotherapy. But I was very lucky because I had a loving and supportive family and many supportive physicians." Being diagnosed with cancer only strengthened Brinker's commitment to finding a cure for breast cancer.

Nancy believes that helping other people is the secret to happiness. "It's very easy in America to get wrapped up in material things. You have to be careful about that. At the same time, you have to enjoy life."

As a testament to her joyful philosophy, many of her projects are fun. "I think we grew up in a time between Disney and Sesame Street. We're of that generation of people that likes to be entertained while being educated." The Komen Race for the Cure is a breast cancer fundraising and awareness-raising event that Nancy initiated. Seventy-five percent of the proceeds stay in the community where the race is held, and is used to support educational initiatives and breast cancer screening and treatment programs. Twenty-five percent goes to the Foundation's national research fund.

In 1998, the scope of the Komen Foundation's mandate was expanded to support international projects. "We don't go to other countries to raise money. When invited, we go and help them with their efforts to eradicate breast cancer." Work has begun in Italy, Greece and Germany.

Joint ventures with government, non-governmental organizations and corporate sponsors are a big part of the Susan G. Komen Breat Cancer Foundation's work. Its success relies on working with others towards a common goal.

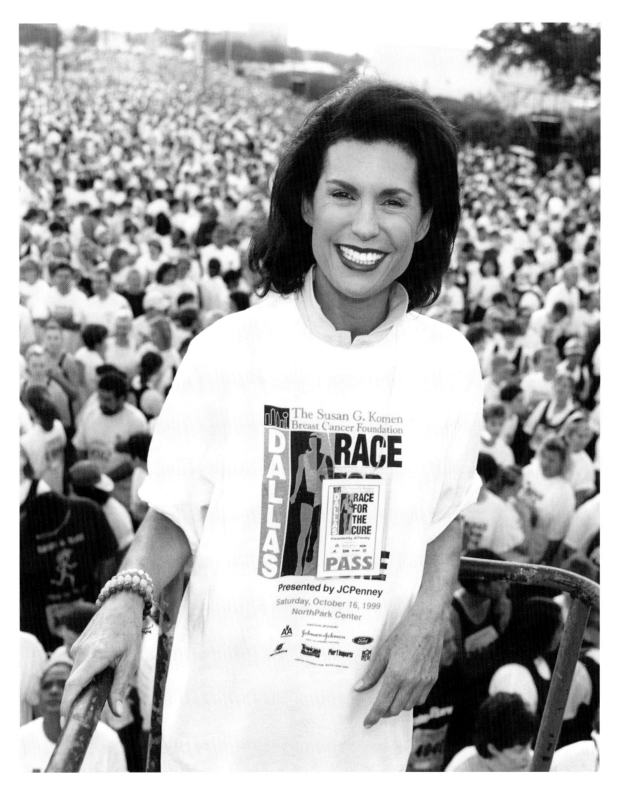

"Life isn't a dress rehearsal.
Every day, do something that is important to you, something that feeds your soul.
Give back, because if you don't, you will start to feel empty."

DR. HELEN CALDICOTT

Dr. Helen Caldicott likens herself to a "Cassandra," a prophetess who predicts misfortune and disaster, and is shunned and disbelieved because people don't want to hear or accept the truth. Caldicott warns: "I see no world if we continue going the way we're going. We're killing the earth. Within a hundred years, two thirds of the world's 30 million species will be extinct, and we will have done that. I see the ozone disappearing. I see global warming as an absolute reality, with all the disastrous by-products that entails. My grandchildren will have no future if we keep this up. I can hardly bear to think about what the world will be like in fifty years."

In 1980, Dr. Helen Caldicott, a longstanding pediatrician and Harvard Medical School instructor, resigned from her life in medicine and became an anti-nuclear activist and educator. The seed of this life-changing decision was planted in 1971, when she learned that France was testing nuclear weapons in the South Pacific, near her native Australia. She quickly wrote a letter to a local newspaper detailing the harmful effects of radiation. The mainstream media picked up the story and only a few days later her life would never be the same. As a result of the immediate public interest, Dr. Caldicott became an international spokesperson for the growing nuclear disarmament movement. She combined her medical knowledge and leadership abilities to organize rallies and protests, and boycott French products. One year later the French government halted nuclear testing.

While living in the United States from 1977 to 1986, Caldicott founded the organization Physicians for Social Responsibility. They are a group of more than 23,000 dedicated doctors who are committed to educating their colleagues about the dangers of nuclear power, weapons and war.

Helen Caldicott is a mother of three, and her surrogate children are the people of the world. She believes that "Money is the root of all evil. Life isn't about money. It makes people greedy, selfish, competitive and nasty." Dr. Caldicott is especially concerned about the welfare of children: "Children aren't consumers, they're children. They shouldn't learn about money until they're older. But in this society, money is God."

Her advice to parents raising children today is: "Don't show them any television. Don't let them play video games. Don't let them use computers. Let them play outside. Don't give them lots of toys, let them make their own. Let them climb trees and let them fight and argue and roll around like puppies. Let them be creative and have their own games. Don't rush them around in great big cars producing carbon dioxide and causing global warming."

It's been a tough battle educating and proselytizing the masses. Dr. Caldicott's message to people is: "Live your truth and be courageous. For Christ's sake, be courageous. Everyone's got their own truth, everyone knows what to do. Everyone knows that what's happening now is that we're really killing the earth. Have some guts."

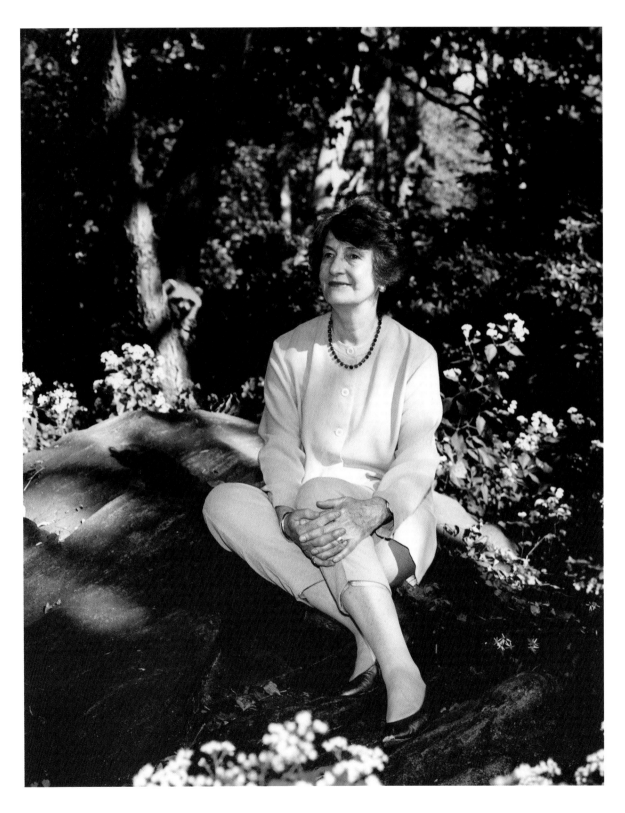

"Integrity is being honest with yourself, and being honest in your intimate relationships, as well as with everyone else. It's speaking the truth as you see it, and not needing to be approved of or wanting to be needed. Just go for it!"

ANNIE CHAU

Annie Chau celebrates life by working hard and helping others. In 1997, when she was seventeen years old, Annie founded ArtSpan. This after-school art program, run by volunteers provides creative learning experiences for underprivileged, troubled and disabled children in San Mateo County, California. "Art is a way for people to express their needs, desires and feelings; and it's also fun."

Born in 1981, Annie emigrated from Hong Kong at the age of ten. She knew that not all children were as privileged as she was, that not all children were able to take art classes paid for by their parents. When funding for school art programs was cut, she saw an opportunity to help other kids: "I had the ability and the desire to put my volunteerism and my love of art together."

She cites her older sister and parents as mentors and supporters of her idea to start ArtSpan. "My parents taught me that if you work hard, then you get what you deserve. That has helped me through school, to keep good relationships with friends, and to work hard to build a good program at ArtSpan."

ArtSpan has a volunteer base of approximately twenty high school students who have taught over 250 youths. The program operates in four cities, and Annie hopes to expand its operations.

Annie Chau has accomplished a great deal and gained many accolades that recognize her academic and philanthropic accomplishments. In 1999, she was honored by the "Seventeen/CoverGirl" Volunteerism Awards and had the opportunity to have lunch with Hillary Clinton. Annie is currently studying economics and math at Stanford University, California.

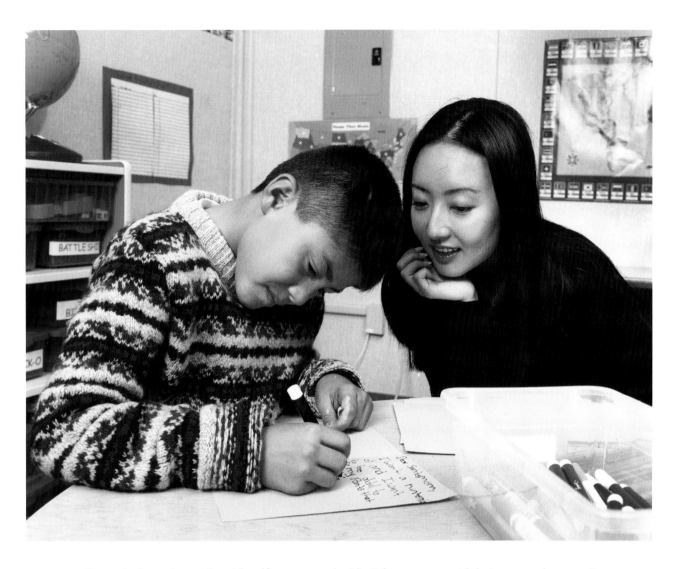

"Integrity has a lot to do with self-respect and with righteousness, with being a good person."

Marcus Gebhardt and Annie Chau

DIANE DUPUY

Diane Dupuy is the President and Founder of the internationally recognized black-light puppet theatre troupe, Famous PEOPLE Players. Established in 1974, this professional group of mainly developmentally-challenged individuals, entertains while encouraging people to evaluate their attitudes towards people with disabilities. The fanciful stories, skits and musical numbers they perform often use show business celebrities as characters. The Famous PEOPLE Players has a permanent dinner theatre troupe located in Toronto, Ontario, and another group that tours extensively.

Diane traces her drive and professional success back to her difficult childhood experiences. "When I look back on my life, I am full of gratitude for those experiences of not being accepted, and being called names. If that hadn't happened, I probably wouldn't have my life's mission today. Sometimes it's your enemies – the people that gave you the hardest time – who become your greatest teachers. I firmly believe that everything in life happens for a reason. We have to find out what that reason is. We have to dig deep inside our souls to discover our gifts, and then dedicate the rest of our lives to developing them."

Dupuy's Roman Catholic faith has given her the power to fulfil her mission. She devotes herself to prayer and meditation, which gives her the strong foundation she needs to persist in her dream. When asked what people should do to find their life purpose, Diane suggests that people meditate. "They have to sit in silence, and listen to their souls. Too many people are going outside for the answers. It's sitting in an empty church or room, asking your heart to give you a sign, then being observant as to what happens…When you find peace within yourself, the world will be at peace."

Diane is the author of two best-selling books, *Dare to Dream* and *Throw Your Heart Over the Fence*, which chronicle her life's work. She has been honored as a Member of the Order of Canada, for her groundbreaking and creative work as an advocate for the developmentally challenged.

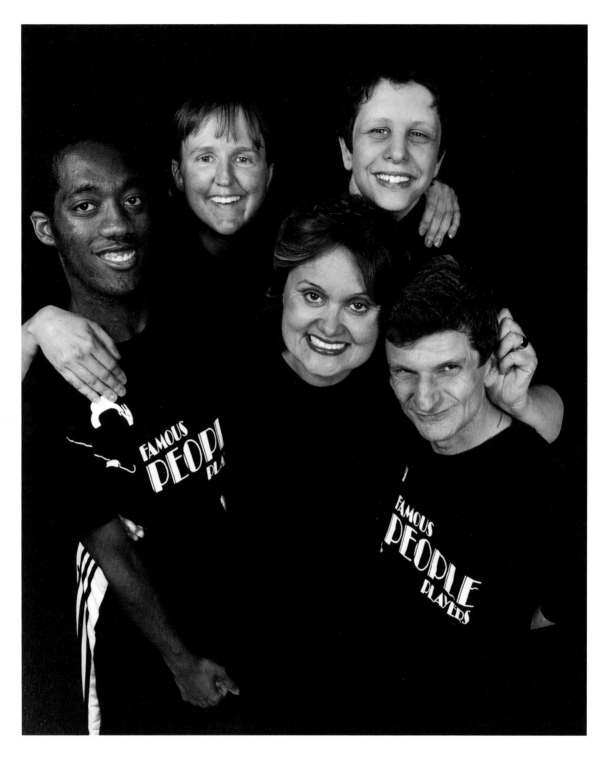

"How do I define integrity? Somebody who has established what they are all about, and what their personal commandments are, and can live by them. 'Today may be your only opportunity to be the Bible, to let someone hear the Bible through you.' What examples we can be!"

Left to right: Marlon Williams, Darlene Arsenault, Diane Dupuy, Else Buck, Greg Kozak

DEANNA DURRETT

Deanna Durrett has been a radical anti-smoking youth activist since she was thirteen years old. Pictured here at eighteen, Deanna lives in Kentucky where they have the 4th highest rate of tobacco use among adults and youth (about 37% of the youth smoke), and where tobacco is the number one cash crop.

After winning an essay-writing contest in grade seven, Deanna was selected as one of two youth ambassadors from the state of Kentucky to attend a national conference called "The Smoke-Free Class of 2000." At the conference, they learned about the health hazards of smoking, and how they could work to create a smoke-free society, in partnership with local health organizations like the American Lung Association.

Deanna's anti-smoking lobbying has taken her to Washington, D.C., where she relentlessly confronts the policy makers, and speaks out publicly to raise awareness about the dangers of smoking. Once, when she was passing out pamphlets to state legislators, to garner support for an anti-smoking bill, several of them got out cigarettes and cigars, lit them, and blew smoke in her face. Deanna comments, "It was very discouraging, but opposition makes us stronger."

Deanna Durrett's relentless efforts have garnered public attention and acclaim, including guest appearances on "Larry King Live," "Oprah," and meetings with former President Bill Clinton and Vice-President Al Gore. She believes that even though she hasn't won a political victory by getting a government bill passed, if her public awareness campaigns and efforts lead to one teenager not smoking, then her work has been worth it.

Durrett's ultimate career goal is to be a White House correspondent or advisor to the President. One of the traits that has helped her achieve her goals is "being able to see a problem and not think about anything but working to fix it." This ability to focus on a vision and her desire to "become the best that we can by helping others and by doing God's will" have led her towards self-actualization.

When asked what her message for young people is, she says: "Young people need to set goals and believe in themselves, to go against all odds and accomplish their goals. Work for your dreams, and become what you want to be."

"Stand up for what you believe in and stand up for who you are. Don't let outside pressures change what you truly believe in. If you have integrity, you know what is right and what is wrong, and you work for what is right."

DR. WAYNE DYER

Dr. Wayne Dyer is affectionately known to his many fans as the "father of motivation." He is primarily known for his motivational books and lectures. His cathartic book *Your Erroneous Zones*, spearheaded the self-help movement.

When Wayne was very young, his father abandoned him. Wayne spent his early childhood in orphanages and foster homes on the East Side of Detroit because his mother could not afford to support her three boys. After he turned ten, she regained custody of the children. According to Dyer, he gained a lot of strength from those challenging years. In 1974, Wayne forgave and made peace with his father. It was at that moment when all the pieces of his life seemed to click into place.

Dyer is the author of twenty books and hundreds of motivational tapes. He has given thousands of seminars, has appeared on many radio and TV shows, and been the subject of numerous magazine and newspaper articles. Two of his books, *Manifest your Destiny* and *Wisdom of Ages*, were the subject of public television specials that aired in 1998. Dyer's writing has mirrored his personal evolution. His latest book, *There is a Spiritual Solution to Every Problem*, explores practicing and living unconditional love on the path to spiritual development.

Wayne Dyer has become a popular culture icon. With profound yet straightforward commentary, Dyer unravels the meaning behind common human problems. He offers compassionate, practical advice that flows from his life experiences. In a non-judgmental way, he helps people to help themselves. Dyer points to the need for us to take responsibility for our actions and not blame our genetics, our environment, or whatever else we blindly grasp. This, he believes, is the most useful tool for spiritual growth.

"You are the sum total of your choices."

ARUN GANDHI

Arun Gandhi is the grandson of India's great political leader and teacher, Mohandas "Mahatma" Gandhi. A leader, teacher, writer and public speaker, Arun Gandhi builds on his father's and grandfather's legacy of direct social action based on the principles of truth, courage and nonviolence. Arun Gandhi expounds his views in five books, and tours the world, giving lectures on nonviolence and the spiritual teachings of his forefathers.

Born in South Africa in 1934, Arun experienced the reality of apartheid from an Indian perspective. He grew up on a hundred-acre farm known as Phoenix, in South Africa. Phoenix was established by his grandfather in 1903 as the first Institute of Nonviolence. After a bitter personal taste of violence, Arun visited his grandfather in India for about eighteen months, between the ages of twelve and fourteen. There he learned more about his grandfather's humanitarian work and his nonviolent ways of dealing with the fierce racial policies of the day. Arun returned to India when he was twenty-four, married, and worked as a journalist.

Arun and his wife, Sunanda, were very conscious of the problems and difficulties that society faced in India, especially the low-caste, labeled "untouchable" who lived in poverty. Arun and Sunanda decided to devote their time and talents to helping people rebuild their self-respect and self-confidence. Arun explains: "Grandfather always said we should never act out of pity, but always out of compassion. When we act out of pity, we generally do something that is not lasting. For example, when we give somebody money to go buy some food because they are hungry, we're just giving that person some solace for a day or two. It's very temporary."

In 1960 Arun started an economic self-help program for the untouchables, called the Center for Social Unity. Arun and his friends lent villagers start-up money to buy cattle and a co-operative dairy was established. Today 500,000 participants contribute to this project, which is active in over 300 villages. The project puts the means of economic self-sufficiency back into the hands of the people.

"The caste system in India is, in one sense, a very natural system that exists in every society. It's the division of society according to professions. For instance, intellectuals tend to bond and work together; people who have the ability to manage people group together; businesspeople form another group, and so on. These kinds of divisions are, to some extent, natural. What is unnatural in the Indian situation is that 2000 years ago, we made the whole system legal. We made social divisions and people's social status hereditary. We created tremendous discrimination and economic disparity. As a result, people do some bad things… It is suggested that these people are born that way, but people are not born bad, they are made that way by society." Arun and his followers see the perpetuation of economic disparity, and the problems that poverty generates as the root of all religious intolerance and violence.

"I like the way grandfather defined spirituality. He said that religion is the normal practice of human beings. When we are able to move beyond religion to spirituality, we can then look at the different religions as being equal, and respect all of them equally. When we cease to be Christians, Jews, Hindus and Muslims, and we are just human beings, we elevate ourselves to that spiritual being."

Arun Gandhi's message for people is: "Everything has been very negative because of selfishness and self-centeredness. I would like people to let love, understanding and respect dominate our lives, rather than suspicion, hate, prejudice and selfishness."

"We should be concerned about other people and not just concerned about ourselves."

URI GELLER

Uri Geller is renowned for his astonishing psychic powers and showmanship. His gifts of telepathy, psychokinesis, clairaudience (the power to hear things outside the range of normal perception), clairvoyance, dowsing and healing are familiar to millions of people. Acutely aware of his own powers, Geller now teaches others how to heal themselves. In his book *Mind Medicine: The Secret of Powerful Healing*, he explains his holistic approach to self-healing. Uri Geller believes that by learning to love and take care of yourself, you can improve your quality of life, and love and care for others more effectively.

Geller's personal life has been anything but typical. "My introduction to life was horrifying because I came from a very poor family, my parents divorced, and later on in life I found out that I was my mother's ninth child. My father hadn't wanted children, and had forced my mother to go through eight abortions." Geller has since forgiven his father, "My only regret is that my father never saw my children. He died before they were born."

As a child in Israel, Geller discovered his ability to manipulate objects with his mind and later developed his other psychic skills. By 1971, Uri Geller had gained international recognition. He credits former Israeli Prime Minister Golda Meir for jump-starting his career; when asked what her predictions for the future of Israel were, Meir had replied, "Don't ask me, ask Uri Geller."

Geller remembers those years as very difficult. "I went back to Israel, joined the paratroopers for the Six-Day War and killed a man. I still have recurring nightmares about that Jordanian soldier. Then in the 1970s, it was all fame and fortune for me. I was on one big ego trip. I abandoned my friends and didn't care about anyone. Slowly but surely, that changed. My character changed and I transformed my values to be closer to what they are today."

Skeptics and critics have played a big part in directing the course of Geller's career. In 1974, as a way of counteracting criticism and proving the legitimacy of his work, Geller took part in a series of highly controlled scientific experiments in Germany and California. Geller demonstrated his paranormal, perceptual abilities convincingly at the Stanford Research Institute, Stanford University, California.

Among the many feats that showcase Geller's psychic prowess is his ability to bend spoons, and stop England's Big Ben. When asked what happens to make the spoons bend, Geller replied, "I don't know. Professor Brian Josephson, who won the Nobel Prize in Physics in 1973, has a theory. He believes that what I am doing is drawing energy from you and from things around me, and I'm bumping it into the spoon. It's quantum mechanics. What the energy does is simply alter the molecular structure of the metal and it starts bending."

When Uri Geller demonstrates to children how they can germinate a seed in the palm of their hand, or make spoons bend, their imaginations light up. He attributes their ability to copy his example to their open minds, and allowing the power to work for them. He believes that the power to do these things is within us all. "I think that we can tap into the universe of energy out there. I am beginning to believe that there is a master plan above us, that God created us all, that there is a reason for being, and that we're all connected. There is an invisible thread of spiritual energy that attaches all humanity together and probably the universe."

Uri Geller has written many books that explore myths, magic, spirituality, healing and the purpose of life. A gifted public speaker and metaphysical expert, Geller motivates and empowers his audience through stories of his own trials and tribulations. His message is clear and simple. "I tell people to stay positive, to always be optimistic and believe in themselves. If you smile a lot, good things will come your way."

"Integrity is being honest with yourself, projecting that to others, and being honest in life."

DR. JANE GOODALL

Dr. Jane Goodall, as her name suggests, exudes the sweetness of a child. Unassumingly portrayed in this photograph with her toy mascot, "Mr. H", Jane is a well-known and respected scientist, conservationist, and environmental activist who crusades tirelessly, lecturing, writing and teaching the precepts of ecological sustainability. In the 1960s many photographic articles were published by National Geographic magazine, which introduced people around the world to Jane's primate research in Tanzania's Gombe National Park, and to her beloved chimpanzee subjects. Today, her work is more broadly focused on educating the public about their role in preserving our precious natural world. Her book *Reason for Hope*, reflects on her spiritual life journey and what intrinsically gives her hope.

Jane states that she is a born optimist. "My optimism stems from my faith in humanity – from the strides that we've already taken, and the human brain and its ingenuity. We say that we've gone too far in destroying the planet, that it's too late, but 100 years ago going to the moon was science fiction. Fortunately, we've come to admit to the environmental destruction that we've perpetuated, so can't we come together with our brains around the world and start healing the scars and living in ways of great harmony?" Jane cites this example: "After the Nagasaki bombing, scientists predicted that nothing would grow for maybe 30 years, in fact, the green came back quickly. A wonderful sapling didn't even die; and now it's become a big tree. I always carry around a symbol of hope, a leaf from that tree."

The greatest influences in Jane Goodall's life have been her mother, who helped develop who she would become, and Dr. Louis Leakey, the paleontologist and anthropologist who gave Goodall the opportunity to first visit Gombe in 1960, to study wild chimpanzees and discover her life's work.

The "Roots & Shoots" program established by the Jane Goodall Institute in 1991, is the focus of her energy, and is the driving force behind her world travels. It encourages young people, from preschoolers to university students, to improve the environments we share and make their world a better place for animals and people. Goodall believes that "If young people understand a problem, are made to feel that they as individuals matter, and are empowered to act, their energy and commitment can be huge." The Roots & Shoots program is now active in almost seventy countries, and successful in classrooms, youth groups, and even institutions such as prisons and homes for the aged, where inmates and residents are involved in a variety of projects: growing vegetables, making bird boxes, and planting flowers and trees. Participants report that the Roots & Shoots program renews their sense of self-worth.

Jane Goodall's message to people is that "Every single individual makes a difference. We tend to think that we're one person in a world of 6 billion, so what we do doesn't matter. Yet millions of educated people can make a difference in our affluent consumer society, through the choices we make – from the cosmetics we buy, to the food we eat." Jane believes that if we begin to make ethical choices in areas that we have control over, positive changes will occur faster than through formal legislation.

Jane is brimming with ideas on a vast range of subjects. Her analytic mind and compassionate spirit have meshed to provide the world with a wonderful teacher and a reason for hope.

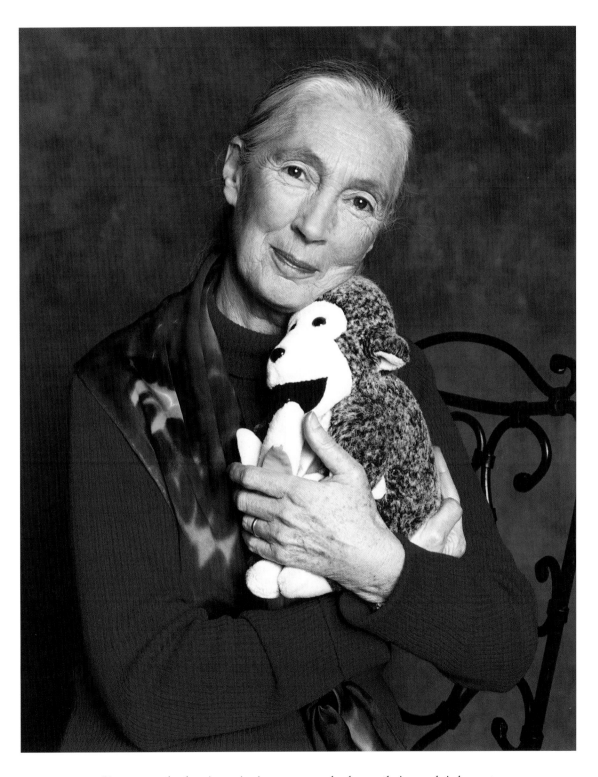

"A person who has integrity is someone who keeps their word, is honest,
tries to live by a set of values, and doesn't betray them."

JERRY GOODIS

Jerry Goodis is a marketing man with scruples. He has had a highly-regarded career as a marketing and advertising executive, as a tactical advisor, speechwriter, communications counselor and policy consultant for former Canadian Prime Minister Pierre Elliot Trudeau; and more recently, as an independent consultant, educator and public speaker. Goodis currently serves as an advisor to the Faculty of Business at the University of Victoria, British Columbia.

Jerry Goodis made himself a name by supporting ethical business practices, which complemented the liberal idealism of the 1960s and 1970s. Goodis refused to work for the Department of Defense, or to promote tobacco, war toys and shoddily designed goods. He explains how MacLaren, his advertising agency, operated: "We had no interest in taking on a product that was socially unacceptable. When it came to political, economic and cultural issues, we took a stand. We would not abide in any way with any kind of discrimination within our company, and we certainly wouldn't handle products that promoted immoral activities...We always sold our products on their merits, and rarely attacked the competition."

Goodis's social conscience was inspired by his father, who was a trade union organizer. "At the risk of sounding trite, I believe that all humans are equal, regardless of race, religion, creed, color or gender. There's not a drop of malice in my body towards gays, blacks, whites, greens, purples, men or women. Good people are good enough for me. That was a pretty left-wing point of view, especially in the 1940s and 1950s." Goodis wishes that everyone would learn to put their religious differences aside and "learn to live together, especially in places where there is so much killing, like Ireland, the Middle East, Yugoslavia."

Goodis's righteous stance against promoting smoking and war toys, and his success in business, initially made him and his colleagues, in his own words, "a bunch of pompous jerks...But eventually I grew up. I came to realize that we're all the same, that we're all essentially good human beings. We're put on this earth to help one another, to be happy and productive."

"Integrity is fulfilling commitments you make to your fellow human beings."

DR. BILLY GRAHAM

Dr. Billy Graham is an internationally renowned Christian evangelist. He was born in 1918, in Charlotte, North Carolina. His ministry has been very successful at using the media – television, film, print and radio – to preach the Christian gospel around the world. The live crusades, which are the heart of his ministry, have attracted crowds totaling more than 210 million people.

During a visit to Toronto, Ontario on June 6, 1995, Billy Graham delivered a speech that outlined the leadership qualities he believes are needed in the twenty-first century, they include: integrity, personal security, and a sense of priority. "Integrity means moral honesty and purity in our lives. It means having firm moral and spiritual standards, and following them. It means refusing to take the shortcuts that no one may ever know about, but are nevertheless wrong. Integrity means being the same on the inside as you claim to be on the outside. If you have integrity, there is no discrepancy between what you say and what you do. Solomon wrote long ago: 'The man of integrity walks securely, but he who takes crooked paths will be found out.' (Proverbs 10:9)

"The second quality that I believe is necessary for leadership is personal security. I do not mean physical security or job security, but I am talking about personal, internal security – the kind that comes from knowing and accepting who we are, why we are here, and where we are going. I am not talking about having self-confidence, or a strong ego, or a sense of personal security that comes from your own talents or the approval of other people. The personal security I am speaking of comes from an understanding that we are God's creatures, and that He has a plan for our lives. The third quality that is necessary in a leader is a sense of priority. This is the ability to separate the important from the unimportant. Until a person gets his or her priorities straight, everything else is going to be out of order.

Since 1992, Billy Graham has eased back in his work schedule because of Parkinson's disease. Graham's eldest son, William Franklin Graham III, is now vice chairman of the Billy Graham Evangelistic Association Board, and will become his father's successor when the time comes for his father to leave the ministry.

The Gallup Organization has recognized Reverend Billy Graham as one of the "Ten Most Admired Men in the World" forty-three times since 1955." This broad support is a testament to Billy Graham's honesty and positive influence on society.

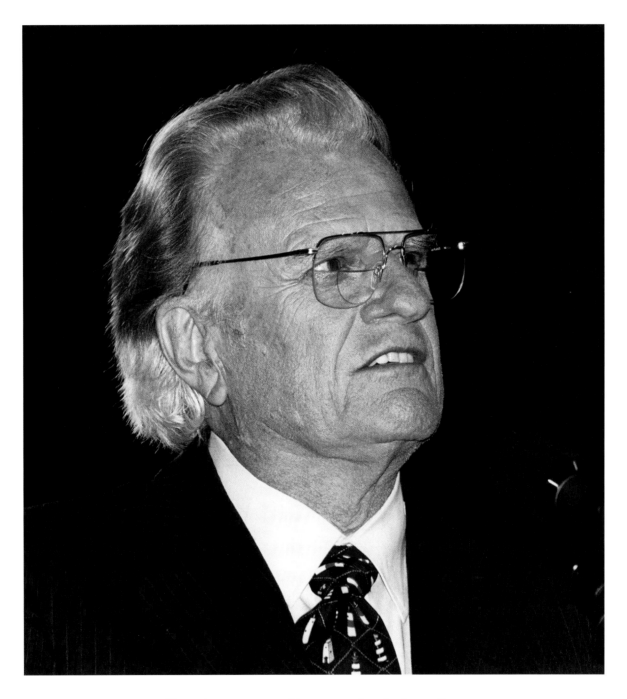

"Integrity means moral honesty and purity in our lives.
Our world needs leaders who are willing to sacrifice their own ambitions and goals for the cause of a
higher goal – the goal of doing God's will, of doing what is best for others and for the world."

DR. JOHN GRAY

Dr. John Gray is recognized internationally as an expert in the fields of communication and relationships. His successful self-help relationship guide, *Men are from Mars, Women are from Venus*, and other books, have sold more than 24 million copies around the world.

Gray attributes his choice to pursue a career in communication and healing to the influence of his mother, who had a spiritual bookstore and was a very happy, fulfilled person. Another significant influence was Maharishi Mahesh Yogi, the founder of the Transcendental Meditation movement, with whom John Gray lived for nine years, and acted as his personal assistant.

"He was my role model for influencing the world in a very big way. I saw that a man could be strong, powerful and influential, and still be a loving, kind person. After that I drew inspiration from all the people who came to me for counseling and from all the books I read. Everybody became my teacher."

Healing emotional pain has been John Gray's main focus until recently when he started studying methods of physical healing practiced around the world. Eight years ago, while traveling in Mexico, a parasite got into Gray's left eye, causing him to go blind in that eye. By practicing alternative approaches to healing, Gray recovered his vision, and this experience led to his interest in developing self-healing exercises.

What makes John Gray's work so popular is that he gives his readers the tools to help themselves, using clear and straightforward language. John emphasizes, "Always follow your heart when making decisions. Do what makes you feel good. Don't let other people's opinions and thoughts take priority over what you feel or believe to be true. When you don't know what is true, seek the help of someone who makes you feel good about yourself. They will get you closer to what is true than someone who makes you feel less than you are."

"Integrity means being true to yourself, keeping your word, and not misleading people."

MONTY HALL

What makes Monty Hall truly special, is not his star on the Hollywood Walk of Fame or his twenty-seven-year career as host of the highly popular game show "Let's Make a Deal," but his incredible generosity.

An Emmy award-winning producer and recipient of the prestigious Order of Canada, Hall began his long-running broadcasting, acting and singing career at CKRC Radio in Winnipeg, Manitoba. After his career took a plunge in 1955, he left Toronto, Ontario and went to New York City to seek his fortune. In New York he worked on shows like "Video Village" in 1960, then moved to the West Coast and sold "First Impressions" to NBC in 1961, and then sold "Let's Make a Deal" to NBC and a series of variety shows to ABC.

Hall's life outside of television has proven to be even more fulfilling than his broadcasting or business endeavors. "The most important thing in my life is my family. I have three children and four grandchildren; my whole life centers on them. My work and charity are tied for second. And recreation comes last."

At over seventy years of age, there is no sign that Monty Hall is slowing down. "I have raised at least $800 million so far for charities, and helped to build hospitals." The neo-natal/pre-natal floor of Mount Sinai Hospital in Toronto, the children's floor of the UCLA Medical Center, and the children's pavilion of Hahnemann Hospital in Philadelphia are all named after Monty Hall. As a young man Hall wanted to become a pediatrician but went into the entertainment business because it was the practical thing to do at the time, and he was very good at it. Some of Hall's motivation for his work in the medical area may be attributed to his early childhood experience as a burn victim. Hall partners with medical professionals to help fund research and realize a variety of patient treatment centers.

Both of Monty Hall's parents came from near Kiev in the Ukraine. His mother and father immigrated to Winnipeg, Manitoba in 1906. Monty's father ran a meat market and his mother helped him run the business. Monty cites his mother, Rose Halparin (Halparin was the family name before Hall changed his name), who was also a singer and performer, as the biggest and most positive influence in his life. Her involvement in charity work inspired Monty and his brother Robert, who are both actively involved in the Variety Club, and are both past presidents. Hall is involved in many charities as a philanthropist, and a participant, acting as master of ceremonies for many fundraising events.

Monty Hall loves people. "The most amazing thing ever manufactured was the human being...God is in my children and my grandchildren. God is in all the beautiful things we see around us." Hall's legacy includes his children, grandchildren and a little bit of him in all the work he's done.

What do they say in Henry VIII? "A little bit of Harry in the night." To which I would add, "A little bit of Monty in the world after he goes."

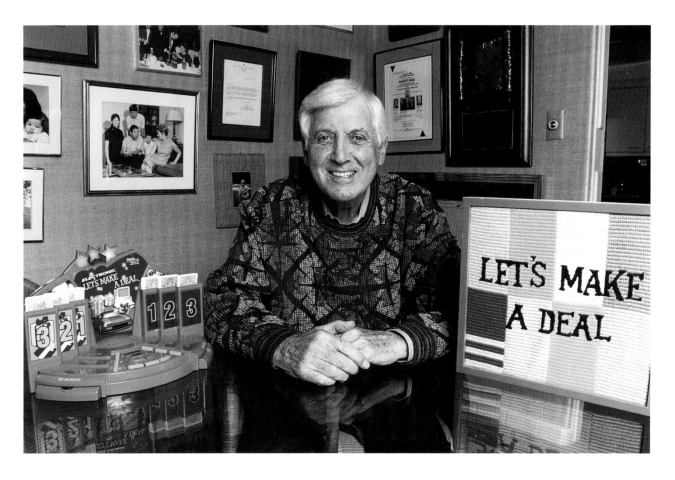

"Your word is your bond. Integrity is making a commitment to something and sticking to it. For example, my marriage has lasted fifty-three years; that's a commitment!"

RICK HANSEN

Rick Hansen's life changed dramatically when, after a day of fishing, he hitched a ride home and the truck crashed, smashing him into a steel toolbox. On regaining consciousness, he realized that he could not feel his legs. When doctors told him, shortly afterwards, that he would never walk again due to a severe spinal cord injury, Hansen's attitude towards life quickly changed: "At the age of fifteen, I measured success in terms of complete independence, strength, looks and power…I had to do a lot of growing up, quickly, or I probably wouldn't have survived."

Hansen drew on the support of his family, friends and mentors during this challenging time. He cites his physical education teacher and coach Bob Redford as a key source of encouragement. Bob reminded Rick of his dreams that, before the accident, all that Rick had wanted to do was teach physical education and be a coach. Hansen explains: "To understand that I could participate in sport, and make choices about being an athlete, and recognize that I wasn't defined by the use of my legs; this was my heart of courage. That drove my pursuit of excellence."

Rick also cites his father as an important influence during his time of crisis: "My father also had an accident when he was quite young. He was a telephone worker. One day when he was climbing a pole, it gave way and fell down on him, fracturing his hip and leaving him with a serious disability. The fact that he got on with his life and made the best of things, that he continued to engage in life in spite of his limitation, really had an influence on me. Had he sat back and whined, I may have approached my disability differently."

Rick's friend Terry Fox also inspired him. "Even though his purpose was to raise money for cancer, I was inspired by his journey, by how people viewed him, and by how his disability was secondary. When people looked at Terry, they saw ability, capacity and potential."

This motivated Rick to make his Man in Motion World Tour. Hansen captured the hearts of millions of people worldwide when he successfully wheeled 24,901.55 miles, the circumference of the earth, raising $24 million for spinal cord research and raising awareness about the potential of people with disabilities. His wife, Amanda, played a key role throughout the Man in Motion World Tour – as his friend, his physiotherapist, and as a strategic component in his life.

After regaining his mobility, Rick became the first person with a physical disability to graduate in physical education at the University of British Columbia. Today, Rick is President and CEO of the Rick Hansen Institute, and works tirelessly to fulfill its mission to accelerate the discovery of a cure for spinal cord injury. He has an insatiable drive and acknowledges that "We all have obstacles and challenges to deal with, and they are all very much a part of learning…My life is a series of new goals and new dreams."

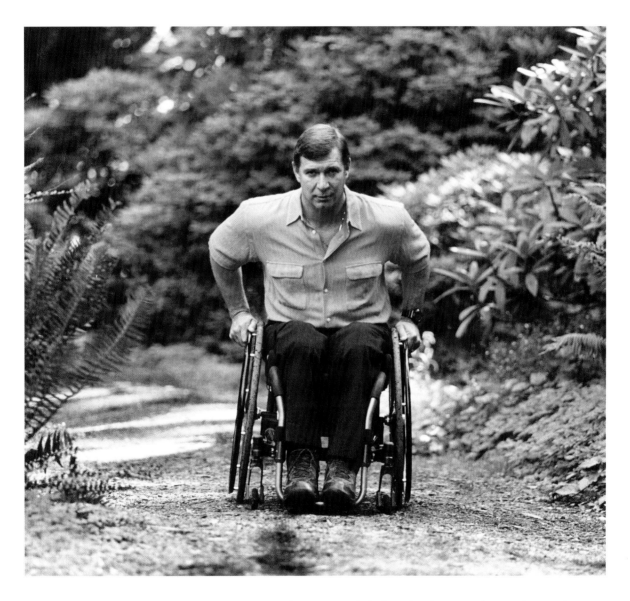

"Integrity is taking the time to first understand what your beliefs and values are; then understand your meaning, your purpose and your priorities; then live life in a way that is consistent with those things. It's living in a way that integrates your actions with your intent. It's also about being open enough to respond, reserving the right to be a better person tomorrow than you were today."

JUDY HENSLEY

Being called "just another dumb hillbilly" by a thoughtless grade three teacher set Judy Hensley on a mission to prove her teacher wrong. Born in Harlan County, Kentucky, Judy's life evolved in ways she never anticipated. Today, she and her students are well known for initiating a movement that saved Black Mountain, in Harlan County, Kentucky, from strip-mining.

Judy Hensley has been challenged by life. "The greatest setback in my life was when my marriage broke apart, leaving me with an eleven-month-old child and no job, home, financial resources or idea where to go from there. Becoming a divorce statistic was nowhere on my list of life expectations. I came out of my divorce believing that I still had a destiny and that God would direct my path, if I trusted Him to do so. The real breakthrough came with the realization that my life was my own, and that it was up to me to make the most out of it." Judy worked three part-time jobs, took classes towards an elementary school teaching certificate, and tended to her son. She also completed a master's degree in education. Judy Hensley's first teaching position was at Wallins Elementary School in Harlan County, Kentucky.

A Foxfire training course, based on John Dewey's philosophy of experimental education, inspired Hensley to go beyond the prescribed text-books and transform her students' learning experience. "This educational approach gives students a voice in the learning process, ownership and investment in the learning that takes place, and avenues of expression and growth that they would otherwise not experience in the classroom." This grounded approach to teaching and learning resulted in media attention and concrete positive results.

Jacob Doyle, one of Judith's former students elaborates: "I was on television news. I've been in magazines and newspapers. I've been on "Nightline".

All of this came about because my class was doing good things for the community, trying to preserve nature's gifts. We worked to preserve Blanton Forest and to save Black Mountain, the state's highest peak. Both of these things happened because my class started them. Although people thought we wouldn't get anywhere, we did, largely because the media got involved and showed the good things that kids can do, instead of the bad."

Justin Harris, another student of Judy's, had this message for people: "Believe in yourself. Believe in God. Know that you can make a difference if you will only let yourself try.. It is important to accomplish things by yourself, but at the same time no one can do everything by himself or herself. It is important to recognize your own importance, as well as the importance of others."

Several other local schools from elementary to college levels were attracted to the project, including the fourth-graders of Rosenwald-Dunbar Elementary in Jessamine County, Kentucky. Teachers, Barbara Greenlief and Sandra Adams, worked with their students to raise awareness of the issues in the Bluegrass region of Kentucky. Kentuckians for the Commonwealth, a grassroots citizens' group, organized adult support across the state and mounted the legal battle to stop the strip-mining on Black Mountain.

During court negotiations between lobbying environmental groups and ten coal and timber companies, which lasted six months, Hensley helped the students maintain their focus, and ensured that work on the Save Black Mountain project correlated with the school's science curriculum.

The citizens of Kentucky rallied together and successfully saved Black Mountain. The State of Kentucky bought mineral and timber rights back from the companies, and consequently almost 12,000 acres have been protected and preserved.

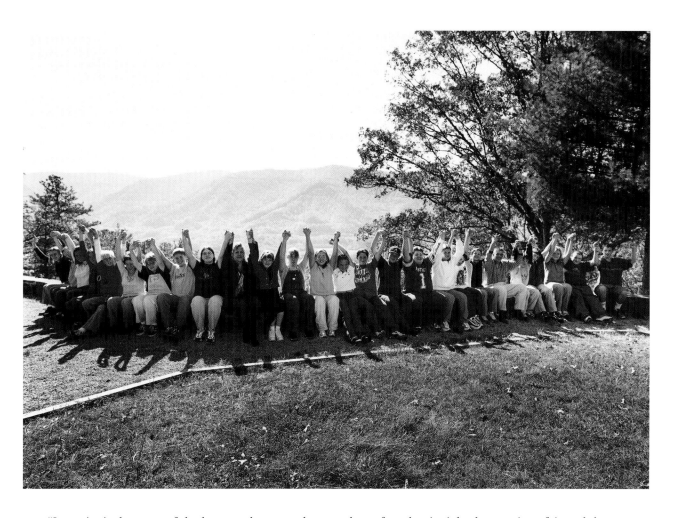

"Integrity is that part of the human character that stands up for what is right, honest, just, fair and decent in the world, regardless of what is popular or convenient." – Judy Hensley

"Having integrity means being completely honest, so that people can believe in what you say and what you do. It means having the guts to say 'no' when you know something is wrong, even if everyone else says to do it. If someone you know gets in trouble and your insides tell you not to tell on them, it means telling the truth anyhow and never lying." – Student Mikey Ashurst

Left to right: Wadonna Watkins, Elizabeth Saylor, Stacy Buell, Courtney Helton, Michael Simpson, Jennifer Freyer, Morgan Niday, Brian Saylor, Amber Jones, Judy Hensley, Kim Humphrey, Ashley Saylor, Stacey Salinas, Ashley Taylor, Jeremy Card, Jacob Doyle, Nicholas Greene, Leeanna Hensley, Charlie England, Shane Smith, Justin Harris, Mikey Ashurst, Josh Cole, Saretta Fugett, Steven Hensley, Aaron Stephens with Black Mountain in the background.

JULIA BUTTERFLY HILL

Julia Butterfly Hill spent over two years perched 180 feet atop a giant California Redwood she called Luna, to protest clear-cut logging by the Pacific Lumber Company a division at the Maxxam Corporation. From December 10, 1997 to December 18, 1999, equipped with a radio-powered phone and pager, she communicated with the media, spoke at conferences, and conducted educational talks without leaving the confines of her six-by-eight-foot plywood treehouse.

Her inspiration was born one day in 1996, when Julia, the daughter of a non-denominational preacher, was convalescing from a serious auto accident. Julia describes the spiritual experience she had amidst the California Redwoods, 230 miles north of San Francisco: "I realized I was surrounded by beings that were thousands of years old...The experience was so powerful and so pure it dropped me to my knees. I sunk my fingers and face into the soil and began to cry... Finally I gave in and said, 'OK, if I'm supposed to be out here, please use me as a vessel for the greater good.' I gave my word to this tree, the forest and all the people, that my feet would not touch the ground until I had done everything in my power to make the world aware of this problem and stop the destruction...Once a forest has been clear-cut it will never be the same."

While camped out high in Luna's branches, Julia endured the coldest, stormiest winter in Northern California's recorded history; severe medical illness; and near-starvation when loggers blocked her food and water supplies. Despite great hardships and powerful adversaries, Julia believed that the lumber company was reachable.

As a result of her protest, clear-cutting in this ancient California forest was halted, Luna and the surrounding area was saved and Hill's mission brought her world-wide recognition.

Julia Butterfly Hill, aptly nicknamed, likens the metamorphosis of a butterfly to her own life struggle "I believe that the environment shapes who we become...We need to go to the higher power for guidance and understand that we are not God, we are not the Creator...The human spirit has to go through that struggle to push through. That is how it releases its old self into its fluid self, and then it slowly spreads its wings and flies out into the universe. That is what happens to us when we let go of fear...Through life's trials and hardships, we rise beautiful and free.

"If a runner is running a race and he or she says, 'I will never win,' they will never win. You have to keep your eyes on the prize and never doubt that you will make the finish line. We have the power to realize the world we'd like to see."

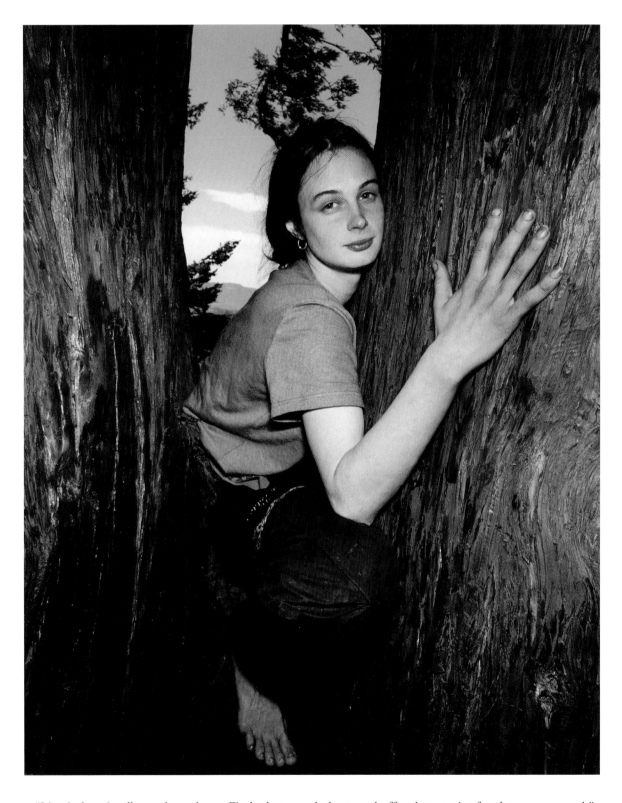

"Live in love in all you do and say. Find what you do best, and offer that service for the greater good."

Photographed from Julia's platform, 100 feet above ground.

GORDIE and COLLEEN HOWE

A self-proclaimed team, Gordie and Colleen Howe continue to astound their fans. Known affectionately as "Mr. and Mrs. Hockey," they have devoted their lives to their family and the sport of hockey.

Gordie Howe, "Number 9," has contributed to the increased popularity of hockey through his dedication and love of the sport. In 1946, he entered the National Hockey League (NHL) at the age of 18. When he retired for the first time in 1971, Clarence Campbell, the president of the NHL said, "Gordie, when you first joined the League, hockey was a Canadian sport. As you exit, you have made it a North American sport!" Gordie Howe has had a brilliant career as a right winger with the Detroit Red Wings, Houston Aeros, and New England and Hartford Whalers and has also played seven professional seasons with his sons Mark and Marty. He is renowned for his smooth skating style, strength and shooting dexterity. By his final retirement in 1980, Howe had set more records than any other NHL player, and he is recognized by many experts as the greatest player of all times.

Gordie Howe's work did not stop when he retired from the game at the age of fifty-two. Together with his wife Colleen, they have nurtured their family of four children and nine granchildren, and inspired by their love of hockey and their fans, created a successful business.

Colleen Howe has not only supported her husband and hockey player sons, Mark and Marty, through their careers, but has also built a thriving business around the family interests. She was the first woman hockey manager and agent, and she formed the first junior hockey team in the United States. "It didn't stop there," says Gordie, "she went to the banks to show them that it was a very viable investment and subsequently, a lot of people got loans and a lot more rinks opened up." Colleen is president of Power Play Publications and Power Play International companies used for marketing and fund raising activities. In 1995, Colleen co-authored and published *and...HOWE!* the latest family autobiography which has generated over $75,000 for charitable causes throughout North America.

In 1993, Gordie and Colleen started the Howe Foundation, its mission is to assist organizations that work to improve the quality of life for children of all ages. They have traveled internationally championing over 150 charitable causes. In 2000, the Howe family received the U.S. Hockey Hall of Fame's Wayne Grezky Award which is given to international individuals who have made a major contribution to the growth of North American hockey. It is the first time the Hockey Hall of Fame has honored an entire family, and the first time a woman has been enshrined in a major hockey hall of fame. A truly beneficent team, the Howes continue to inspire their loyal fans.

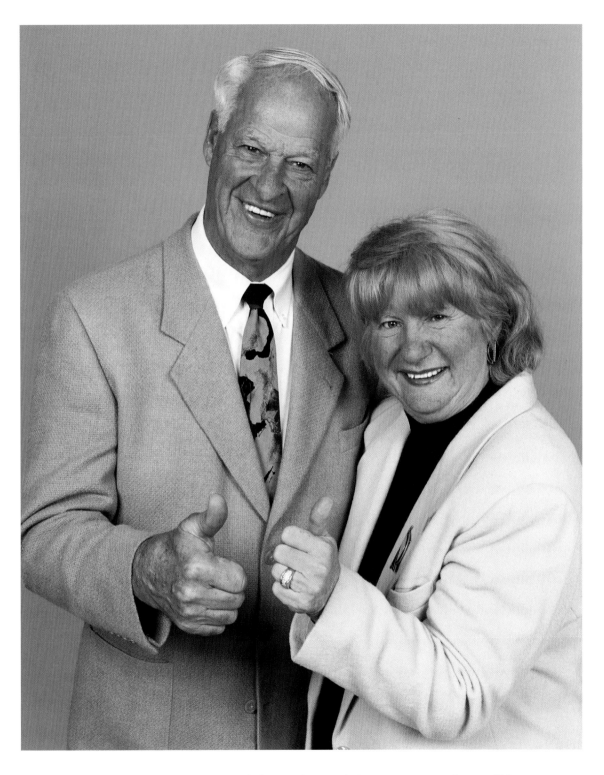

Gordie: "Respect others and their wishes, and give 100 percent of yourself."

Colleen: "I define integrity as what you give to other people through the way you think and feel…
Don't do something that you don't want to do, because you'll never feel comfortable with it.
Also, respect those around you and pass that respect along.
Be the best that you can be, and pass that along."

JAWDAT IBRAHIM

Jawdat Ibrahim is an Israeli Arab from the small village of Abu Ghosh, near Jerusalem. In 1989, while working as a tow truck operator for two years in Chicago, Jawdat won $17.5 million in the Illinois State Lottery. The first thing he did was call his mother and say, "Listen, I'm coming home."

Since returning to his hometown of Abu Ghosh in Israel, Ibrahim has been busy working to bring prosperity to his people. He has helped develop the tourist industry in his village of 6,000, by starting a restaurant, where he works with his brothers and sisters, and by financing a motel. In 1994, Jawdat established the Abu Ghosh Foundation, which is committed to helping people, by mentoring new businesses; financing youth leadership programs, technology training and prenatal care; offering direct cash grants to the very poor to cover their medical expenses; and awarding approximately forty scholarships a year to both Arab and Jewish students.

Ibrahim is sympathetic to the needs of his fellow villagers because he grew up very poor. His mother raised six children on social assistance after his father committed suicide because of a failed business. The family subsequently lived in a basement, with barely enough to eat, no running water or electricity. "We bought our first fridge when I was sixteen years old," Jawdat recalls.

Jawdat's mother taught him to consider everyone a neighbor. "She taught us to accept a person as a person. It doesn't matter what you believe, where you come from, or what language you speak, as long as you're a good person. That's what I grew up with, and that's the attitude I have...I would like to sit here, in this town in Israel, and see countries in the Middle East have open borders and be peaceful. The only thing that people talk about here is how to make money and war. My dream is for people to put their guns away."

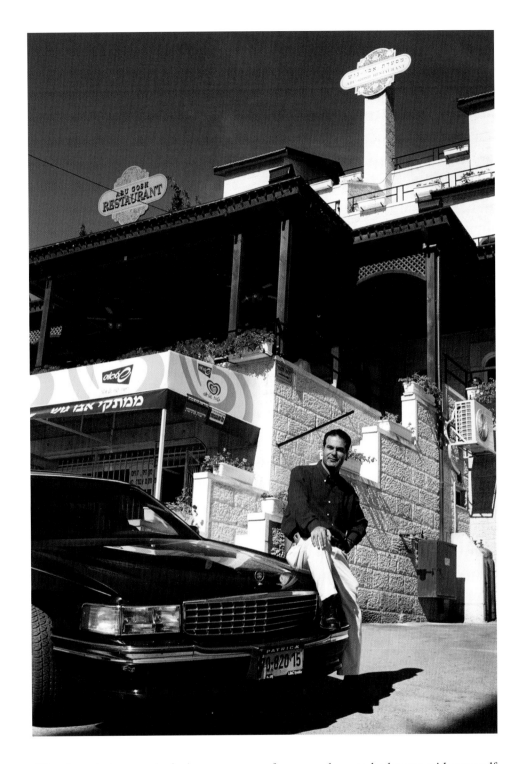

"You have to be proud of where you come from, you have to be honest with yourself
and with your community, and you have to show respect to everybody."

GRAHAM KERR

Graham Kerr is known as the popular host, chef and bon vivant of the television cooking show "The Galloping Gourmet." Originally produced in New Zealand and Australia, the show has gone through many transformations over the years, and now airs on The Food Network. The resilience and hard work of Graham and his wife, Treena, who produces the show, are the integral ingredients of their ongoing success.

In 1971 a serious accident stopped production of "The Galloping Gourmet" in its tracks. A near fatal car accident left Graham partially paralyzed, and his wife severely injured, both physically and emotionally after a vegetable truck hit them. Their doctor advised them to take some time off.

Later that year, Graham and Treena went on a twenty-four-month sailing trip around the world, to recover from their accident and from being over-extended. Before the accident Graham had been affectionately known as "The King of Butter," but his rich diet did not fare well on the high seas. Forced out of necessity to change his eating habits, he began to see the benefits of a healthier, leaner diet. His wife resisted, finding the food tasteless. After Treena had a heart attack in 1986, Graham, determined to help her recover, began creating nutritious meals, replacing the fat, sugar and salt with enhanced aromas, colors and textures. The shows, called "Take Kerr" produced by CNN in 1978, were developed out of those lifestyle changes.

Three years after their accident, Treena became a born-again Christian. Graham followed suit three months later because, as he puts it, "We had exhausted all human understanding about how to repair our life...For all of what the medical fraternity was unable to do, God accomplished literally in one night. Treena was healed. The physician came to see me, his eyes filled with tears, and said, 'I believe in miracles. I've never been able to see one, but your wife's case is an absolute miracle. From sixty-five milligrams of Valium a day to zero overnight, you just can't do that.'"

Kerr sees a redemptive purpose in this life. "We can't know what every human soul is going through spiritually. We just know that all things work together for good in relationships. If it takes a tragedy, it takes a tragedy."

Graham Kerr explains his success. "I'm Mr. Plod. Galloping is one thing, but plodding is another. Behind every galloper, there is a plodder. I work long hours, I'm very patient, and I pursue the truth; I nail it down and will not go forward until I've got it right."

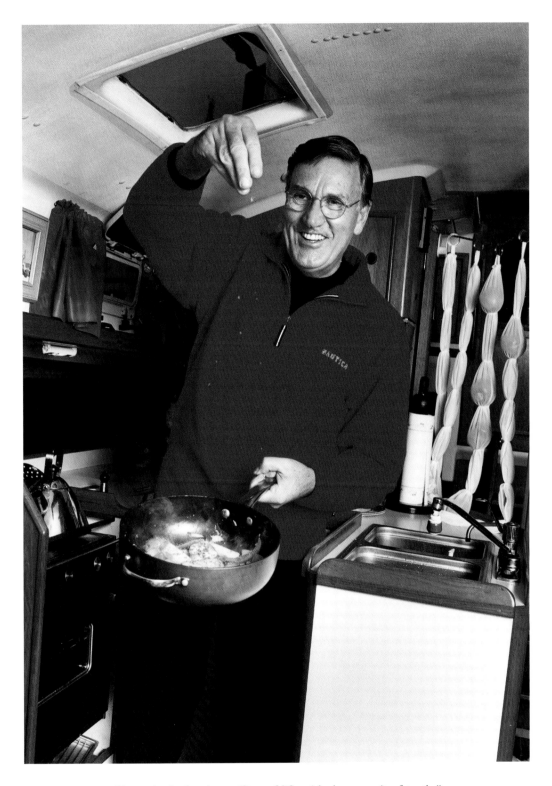

"Integrity is the dovetailing of life with the pursuit of truth."

CRAIG KIELBURGER

Craig Kielburger is a young man with a mission. Since founding the Kids Can Free the Children (KCFTC) organization in 1996 at age twelve, he champions the rights of poor working children around the world. Originally, Kids Can Free the Children worked to free children from the abuse and exploitation of child labor. As our work continued, there was another role the organization had to play. Now we also work to free children from the idea that we are not smart enough, old enough or capable enough to bring about change. KCFTC is the largest children-to-children self-help network in the world."

It all started when Kielburger read a newspaper article that dramatically influenced his direction in life. A 1995 news story documented the plight of Iqbal Masih, a twelve-year-old boy from Pakistan who was murdered after he spoke out against the slave trade, and particularly, child labor in the rug-making industry. This young boy had been sold in bondage, at age four, as a weaver to a local carpet factory to pay off his family's debts. Outraged, Kielburger did more research and rallied the support of his school friends to the cause. "More and more young people started joining Kids Can Free the Children. Soon we had chapters popping up across Toronto, Ontario. The media picked up on our message, helped spread it, and now 100,000 youth in thirty-five countries are involved, challenging world leaders to pay attention to the rights of children.

Considering how much freedom we have in our society, compared to other cultures, Kielburger is struck by how disempowered children are. "It always shocks me when I see how drug dealers in the streets of Rio put more faith in the street children to run their drugs than parents or teachers put in their own children." Given these insights, Kielburger strives to keep the organization as child-centered as possible. In addition to lobbying governments, building schools, and rehabilitating bonded workers, Kids Can Free the Children promotes primary education, develops alternative sources of income for poor families, establishes rehabilitation and education centers in developing countries. Other major campaigns support and promote peace buiding and the reconciliation between children of war-torn regions, and leadership training programs in North America and around the world

Craig's concept of spirituality has broadened since he began his human rights work. "The place where I have felt closest to God is not so much in a church, but in the slums of Calcutta or the streets of Rio. You look around at all these people and they don't have much, but they are all sharing and helping each other survive. They appreciate the simple joys; it starts to rain and they are happy. You look at these people and you think, 'This is how the world should be. Not the squalor, not the poverty, but the sense of community – family that doesn't stop at the blood line.'"

Craig Kielburger's role with the organization that he founded is changing. He has started to play more of a mentor role, working with younger kids, teaching them how to write letters, run campaigns, and continue the work of Kids Can Free the Children.

Kielburger's message to adults is, "Believe in us. Don't be afraid to challenge us, but please don't underestimate who we are and what we can do."

"The way that we bring joy into our lives is by bringing joy into the lives of others…
Look into your own heart and put the needs of others above your own desires
by sharing what you have and standing up for what you believe in."

DUNE LANKARD

Dune Lankard is an Eyak Indian activist involved in environmental and cultural preservation in his ancestral homelands in the Copper River Delta and Prince William Sound, Alaska. As founder, director and spokesperson for the Eyak Preservation Council, he works to conserve the wilderness and wildlife from short-sighted development projects, which in turn affect traditional Eyak culture. Dune and his people are working towards preserving the Eyak and other Native languages in the region. Dune's Eyak name is Jamachakih – "Little bird that screams really loud and won't shut up."

Prince William Sound is one of the finest marine ecosystems in North America, and is currently recovering from the 1989 Exxon Valdez oil spill. A reported 11 million gallons of oil leaked into the Prince William Sound ecosystem. As a result of this disaster Dune's life changed forever. The destruction of his homelands transformed him from a commercial fisherman into a full time environmental activist. Dune and local residents helped engineer a billion dollar out-of-court settlement between Alaska, the federal government and Exxon in compensation for damages to natural resources. The precedent setting settlement was earmarked for restoring and preserving the wildlife and habitat effected by the oil spill.

Dune, a member of his native village corporation board at the time, was opposed to the corporation's plans to clear-cut a 12,000-acre area along Eyak Lake and River, which contained many traditional Eyak sacred sites. As a result of his contraposition, Dune was voted off the Eyak Corporation board, and called a "greenie and a tree hugger" by many of his own people. In response to this he gave up his commercial fishing business and established the Eyak Preservation Council. The Council's mandate is to protect the Delta and Sound from projects that threaten the wilderness habitat, such as roads, logging, oil drilling, mining, and industrial tourism.

Dune remembers a spiritual experience in those years when he was desperately looking for answers to his people's dilemmas. "I walked out alone one night onto a little peninsula in Eyak Lake, a sacred Eyak burial site. After an hour of venting my fears and frustrations to the spirits, I asked for a sign. Suddenly there was a break in the clouds and a circular halo of chartreuse green began to shine in the sky around the summit of Mt. Eyak. The northern lights went crazy, lighting up the night – reflecting in Eyak Lake. An eagle flew over the top of my head and cawed twice. The hair on the back of my neck stood up as silver salmon started jumping out of the water all around me. So, I said, 'now that I have your attention'… use me as an energy conduit and speak Your words to the world."

Many Alaska natives have begun to warm to the idea of land preservation, and now over 750,000 acres of precious habitat in the oil spill region have been saved from clear cutting by agreements between native corporations and the trustees of the billion-dollar oil spill restoration settlement. These deals have provided native people with money for stewardship of their ancestral lands, and have helped them protect commercial and subsistence fishing and hunting in perpetuity. Dune has become a familiar sight on Capitol Hill in Washington, D.C. lobbying for the environmental protection of the Copper River Delta and Prince William Sound. One of Dune's current projects is preventing construction of a 55-mile highway that would be used to access the wild eastern Delta for mining and clear cutting.

"A lot of folks get caught up in the American Dream," says Lankard. "We sometimes forget the priceless value of our remaining wild places. As long as we keep developing them, we will have less of them. I try to remind people that these wild places are already highly developed, producing fish, forests, clean air and water for all of us. What I try to do is show people a different way of looking at things, and inspire them to be proactive, rather than remain reactive to the changes that we allow to happen to our precious environment."

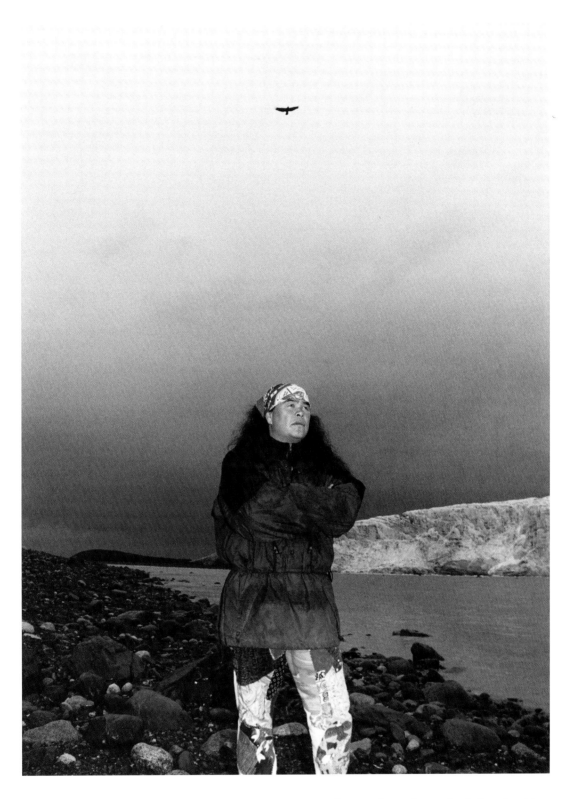

"I see integrity as the voice of reason. As long as I come from a place of sound mind and spirit, I know that every day, there's nothing anyone can say to me that will take me off that path. The wonderful thing about the work I do is that I just have to speak the truth."

SILKEN LAUMANN

Just ten weeks before the 1992 Barcelona Olympics, Silken Laumann – World Champion rower, received a severe leg injury, during her pre-race warm up at a world-class rowing event in Essen, Germany, that threatened her chances of winning Olympic gold. The injury was so acute, that "if I had been a smoker, I am sure I would have lost my leg." The doctors told her that she might never row again. She did not accept that diagnosis, and through perseverance, determination, support from loved ones, and expert medical help, she raced and incredibly won a bronze medal for Canada. "The belief, that anything is possible, and my excellent physical condition were really important to my quick recovery," says Laumann. It was her courageous will to win against all odds that has established Silken Laumann as a Canadian hero.

Silken's next major career hurdle came at the Pan-American Games in 1995, when she tested positive for pseudoephedrine, an over-the-counter cold medicine. It was later recognized that the doping was unintentional, but only after she and her teammates had been stripped of most of their gold medals. In 1996, Silken won a silver medal in the Summer Olympics in Atlanta, Georgia. This win marked her retirement from a remarkable rowing career.

Today, Silken Laumann finds challenge and joy in motherhood, and works as a free-lance writer and inspirational speaker. As a public speaker, Silken talks about how to be successful, and how to overcome your fears and achieve your dreams. "In rowing, fear is sitting at the starting gate and knowing that ten years of work all boils down to seven minutes. I could fail by being so terrified and so overwhelmed that I'm incapable of performing…If I'm really afraid of something, the best thing I can do is to take a mini-step towards facing it. If there's something that I want to do but I don't know how, rather than contemplate it and go around it a million times, I try to take a step towards doing it…The prescription for fear is action."

Silken's rowing accident in 1992 has made her a lot more understanding of other people's situations and how life is full of unexpected challenges. "My understanding and empathy for people has increased. Also, working with people who have addiction or mental illness, has made me realize that people have challenges we don't understand…We can all benefit from being a little less judgmental."

Silken believes that having faith and loving yourself is necessary whether you are creating a marriage, a business or an organization. Today, she finds a lot of joy in unexpected places. "I have come to understand that it's only moments that make us happy. Sometimes it's the really simple joys, like going out and finding some peace on a lake or river, or watching my eighteen month-old sleeping in my arms, or the sound of my children's voices…"

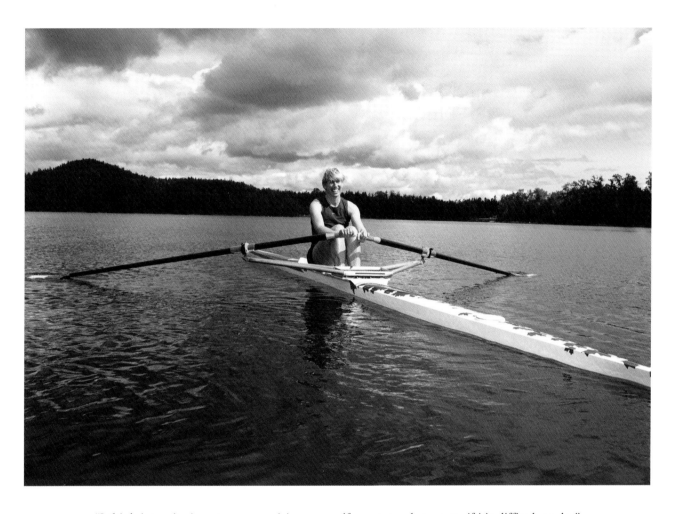

"I think integrity is not compromising yourself or your values, even if it's difficult to do."

JENI LeGON

Jeni LeGon, is a vibrant singer, dancer, actor, choreographer and dance teacher. Born in Chicago, Illinois, in 1916, LeGon developed a love for performance when, as a child, she used to dance, sing and perform skits for neighborhood street audiences. When Jeni signed with MGM in 1935, she became the first black woman to sign a long-term contract with a major Hollywood film studio. She has maintained her passion for dance and performance, despite the obstacles that racial discrimination presented. Jeni has appeared in over twenty films, four of which had all-black casts and gave her a chance to play the heroine, and not just another domestic. She recalls, "I played the role of maid in just about every black culture there is. I've been East Indian, West Indian, African, Brazilian and Arabian."

LeGon made her professional debut as a chorus dancer with the Count Basie Orchestra in Chicago when she was just thirteen years old. She developed a unique athletic solo style, similar to the male tap style of the day, wearing pants, and performing flips and mule kicks. She landed an acting role with Fats Waller and Bill "Bojangles" Robinson in "Hooray for Love" in 1935. During Jeni's career she sang, danced and acted in London, England and on Broadway; and she has performed in many television shows and Hollywood films.

Jeni moved to Vancouver, British Columbia in 1969, and has made it her home ever since. In 1997, the National Film Board of Canada produced "Jeni LeGon: Living in a Great Big Way" which chronicles Jeni's life, how she paved the way for other black women solo performers, and her contribution to dance.

As a dance teacher, Jeni LeGon's advice to her students is: "If you want to do it and you love it, you've got to be dedicated. You have to work hard and produce. When I say that, I mean you have to make it your thing, you have to be the best you can be. That takes a lot of hard work."

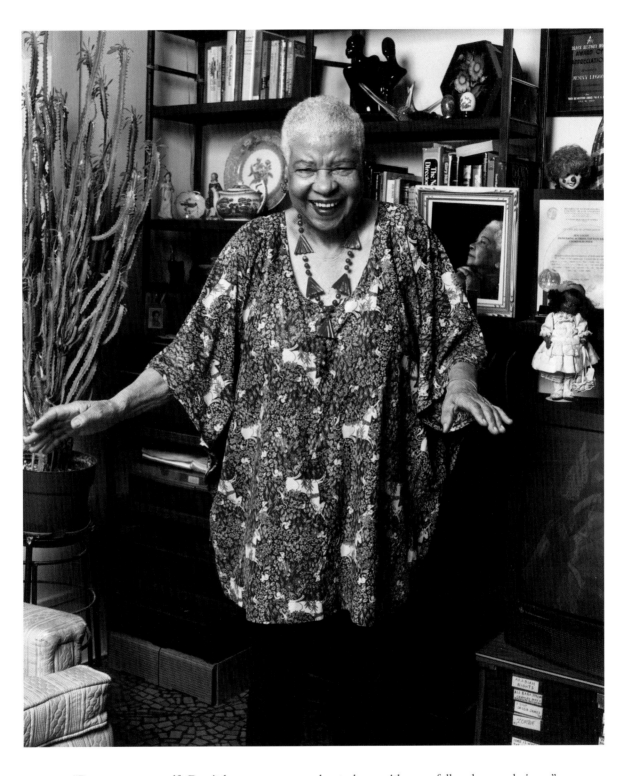

"Be true to yourself. Don't harm anyone, and get along with your fellow human beings."

SENATOR JOSEPH LIEBERMAN

Connecticut Senator Joseph Lieberman is a man of conscience and action. He's a Democrat who works across party lines for his constituents and his country. Since he was elected to the Senate in 1988, Lieberman has influenced government and public opinion on a wide range of issues. He spoke out against the behavior of former President Bill Clinton during the Monica Lewinsky affair, and has fought to protect the Arctic National Wildlife Refuge in Alaska from oil drilling. In 2000, Lieberman was nominated as Al Gore's vice-presidential running-mate, making him the first Jewish vice-presidential nominee to run on a major party ticket. "The overwhelming majority of people judged me on my merits and voted for or against me based on my experience, my position on policies, and how I campaigned, not based on my religion. That's the way it should be."

Joseph Lieberman was born in Stamford, Connecticut on February 24, 1942. He attended Yale Law School where he met Bill Clinton. In 1970, while Lieberman was running for public office for the first time, for state senator, Clinton volunteered on his campaign; and when Lieberman came to the Senate in the 1980s, they worked together again in the Democratic Leadership Council. Lieberman was immensely proud of much of what Bill Clinton accomplished for the American economy, but was disappointed about how he handled the Lewinsky affair. Lieberman felt he owed it to his constituents to make a public statement. In the fall of 1998, he addressed the President, saying, "Mr. President, you haven't acknowledged enough responsibility for your unacceptable behavior." He hopes that acknowledging the moral crisis avoided a constitutional crisis.

Environmental concerns rank high on Lieberman's political agenda. He sits on the Senate Environment and Public Works Committee and is Chair of its Clean Air Subcommittee and believes that when it comes to energy conservation, we can and must do more. "As visitors on the planet, we're trustees for those who will follow us, therefore, we have a responsibility to not exploit and destroy every part of the planet for short-term benefit." Lieberman is concerned about what the Bush administration is planning to do in the Arctic. He does not think America is going to be able to dig its way out of its fuel shortage, and he believes that creative solutions for conserving environmental resources and producing new energy sources such as fuel cells, must be pursued.

Along with conserving and protecting our environmental assets, Lieberman, a father of four and grandfather of two, is interested in protecting society's most precious assets, its children. He lobbies tirelessly against the sources of youth violence, namely the entertainment industries that have a powerful effect on children and their values. He works on behalf of parents across America, appealing to the conscience of the entertainment industry to control its output of negative effluents.

Lieberman's message to people is to "Take every day as a gift from God. Try to do some good work, so you leave the world a better place. Feel a sense of awe and appreciation every day, and try to make the most of every day. Don't forget to enjoy it."

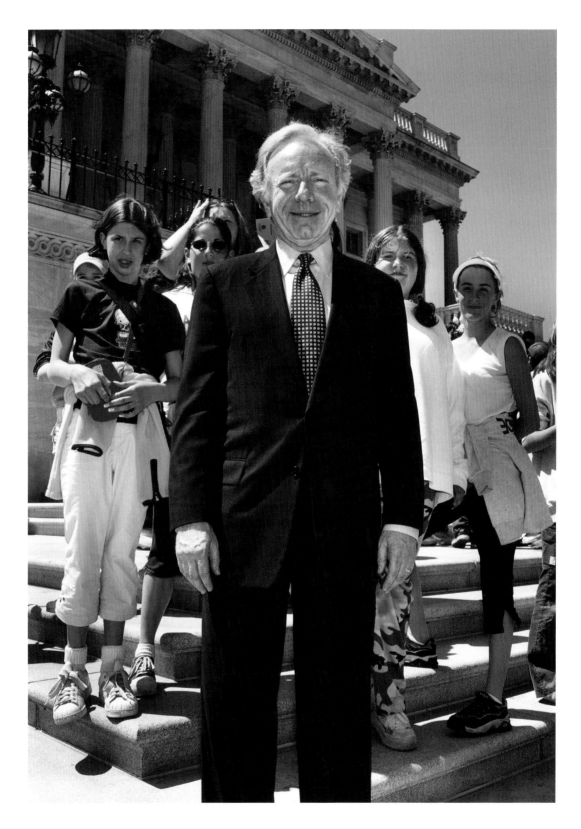

"Integrity is telling the truth. Speaking the truth is being true to principles of right and wrong, especially when no one is watching. Every day I say a prayer, which translates, 'Guard my mouth from evil, and my tongue from speaking guile.' Treat people fairly, directly and with respect."

The Senator with visiting students from Harborside Middle School, Milford, Connecticut.

ART LINKLETTER

A legendary broadcasting personality, businessman, swimmer, downhill skier, surfer, lecturer, writer, father, grandfather and great grandfather, Art Linkletter is a vital eighty-eight years young. "I feel great.. When I surf I take it a little easier now. I don't do ten-foot waves anymore, I just do six and seven-foot waves."

Linkletter views his life as an "absolute Cinderella story – an abandoned orphan blessed by God's care." Born in Moosejaw, Saskatchewan, he was adopted shortly after birth by an evangelist and a shoemaker. When Art was three years old, the family moved to San Diego where his parents worked at the YMCA as secretaries. He grew up wanting to be a secretary at the YMCA and work with children.

When Linkletter graduated from high school at age fifteen, he now claims that girls wouldn't dance with him and that he couldn't play Varsity basketball because he was too little. So he jumped freight trains, became a professional hobo, worked as a sailor on a ship to South America, and came back home at age seventeen, 6'1" and 185 pounds.

Linkletter has a terrific sense of humor, an ability to laugh at life and make the best of every situation. People who have influenced him include Walt Disney, a close friend of his, who he worked and traveled with, and whose "perfectionist creativity" he witnessed first-hand; Henry Kaiser, an associate and an industrial tycoon; and, Norman Vincent Peale, his minister, who taught him the power of positive thinking and rescued him from the depression he experienced after his daughter's suicide. "Peale taught me that things turn out best for the people who make the best out of the way things turn out."

A self-proclaimed type A personality, Art Linkletter is much more than a renowned television and radio personality, recipient of two Emmy Awards and a Grammy, and author of twenty-three books including the top-selling *Kids Say the Darndest Things*. He's also a popular public speaker, who presents to about seventy groups annually, on everything from drug abuse and positive thinking, to oil-well drilling. There is seemingly no limit to his personal experiences and professional accomplishments.

"The oldest message and the only one that is in every religion in the world:
'Do unto others as you would have them do unto you.' Not because you are going to heaven or
because you might go to hell, but because it's the right thing to do. Live your life as if this is all there is."

MAJ. GEN. LEWIS MacKENZIE (RET.)

Major General Lewis MacKenzie (Ret.) had a successful career in the Canadian Armed Forces from 1960 until 1993. During that time, he served in many war zones, including Cyprus, the Gaza Strip, Cairo, Vietnam, Central America and Sarajevo. His most recent and well-know engagement was as United Nations (UN) Commander in Sarajevo during the Bosnian War. Lewis MacKenzie is not only a distinguished military man, but he's also a professional race car driver, a public speaker, and an avid volunteer dedicated to serving his community.

Since his retirement from the military, Mackenzie has had time to reflect on the situations that he has served in. He comments, "There are obvious problems with the way that the international community responds to human disasters." MacKenzie believes that the national self-interest of the United States, China, Russia, France and England – the five permanent members of the UN Security Council – dictate everything. "There is no international self-interest. I wish there was, but there's not. We don't intervene in other people's business because of our values; we intervene because of what's in it for us. That's the cold, hard reality…Paradoxically, now that we've temporarily got the nuclear threat under control, which dominated most of my life, borders count for very little…There are over forty-three wars going on in the world. None of them are cross-border, all of them are internal."

MacKenzie occupies his time constructively, addressing the subject of UN peacekeeping operations and reform. In 1993, he wrote a best-selling book about his UN experiences in *Peacekeeper, Road to Sarajevo*. He hosted a documentary that was based on the book entitled *A Soldier's Peace*, which won a New York Film Festival award in 1997. Also a passionate public speaker, MacKenzie speaks about the "New World Disorder," the fact that in the post cold-war period, the New World Order did not materialize and the world is even more unstable. He has also conducted numerous interviews in the world media, speaking primarily about conflict resolution and UN peacekeeping.

Volunteering for a variety of causes has been a big part of Lewis MacKenzie's life since his retirement. Some of his favorite causes include the International Red Cross, the Special Olympics and the Canadian Federation of AIDS Research. His message to people is, "Take a look at your good fortune, if you're lucky enough to have good fortune, consider paying back a little bit each day. Give back to the community – your local community or the community of nations. I honestly believe that our Canadian obligations abroad are somewhat equivalent to our blessings at home and therefore, we have a fairly large bill to pay internationally. I think soldiers are paying that as much as, if not more than, any other profession in the country."

"Be true to yourself. Integrity is doing exactly the same thing when no one is watching you as you would do when there is a whole crowd looking over your shoulder. That's real integrity!"

DR. PHILLIP McGRAW

Dr. Phillip McGraw came to public prominence as the legal defense strategist and President of Courtroom Sciences, Inc., who helped television talk show host Oprah Winfrey win her 1996 beef-defamation trial. Oprah was sued by Texas cattle ranchers for airing allegedly libelous statements about the potential threat of "Mad Cow" disease to Americans. Today, McGraw is affectionately known as "Dr. Phil" to Oprah viewers and is the show's resident expert on human relationships. He uses his education and experience in clinical psychology, behavioral science and strategic planning, combined with his gifts as an analyzer, thinker and public speaker, to teach people how to live fully while managing pain and conflict.

During the 1970s, as a clinical psychologist, McGraw worked extensively in the area of pain management, and used biofeedback techniques to teach people how to take control of what were previously thought to be involuntary functions. He explained, "Let's say you have neurological pain syndrome due to a broken back. You can have a trauma to the spine that refers pain to the legs and feet, where you will have excruciating pain. You can't do a nerve block because those nerves are needed for the legs to function, but you can control the pain cerebrally. You can voluntarily slow down the bombardment of electrical activity that defines pain."

Training in brain and central nervous system function led McGraw to provide regular courtroom testimony. Phil enjoyed the competitive environment of litigation and in1989 co-founded Courtroom Sciences, Inc., a full-service trial and settlement sciences firm.

When McGraw represented Oprah Winfrey against Texas ranchers in the beef-defamation case, he maintained that she had the right to "freedom of expression." "I was impressed that Oprah took so very seriously the stewardship she had been given by the American public. She recognized how much was at stake. We debated, 'How hard do you think we should fight this?' I said, 'Ask yourself what kind of America we will live in if these people are able to put a muzzle on Oprah Winfrey?' I don't want to live in that America where special interest groups can come and intimidate a clear and right voice…It's about our right to hold this kind of debate in a public forum. It sets a precedent to enable anyone that might want to question an issue of public concern, and say 'We want to debate whether you are behaving responsibly.'"

Today, McGraw encourages his clients and audiences to take responsibility for their own lives, and break free from self-destructive habits. These practical ideas are fully explored in his #1 New York Times best-selling books: *Life Strategies: Doing What Works, Doing What Matters*, and *Strategy for Reconnecting With Your Partner*.

Dr. Phillip McGraw is a passionate fighter, with bulldog determination. "Sometimes when I feel most daunted, most under attack, I think I must be getting ready to do something really significant, or I wouldn't be under such attack. God has a plan and He has a role in it for me. I try to keep an eye on that, and I keep going until He gets me where he wants me to be."

"Integrity is being true to yourself and what you believe, whether it's the popular thing to do or not."

NELSON MANDELA

First as a member of the African National Congress (ANC), then as President of South Africa and recipient of the Nobel Peace Prize in 1993, Nelson Mandela's lifelong work has been to end apartheid in South Africa by establishing peace and eradicating apartheid's legacy of poverty and inequality.

As a young man, in 1942, Mandela joined the African National Congress. The chief contention of many of the younger members "was that the old guard leadership of the ANC, reared in the tradition of constitutionalism and polite petitioning of the government of the day, were proving inadequate to the tasks of national emancipation." In 1944, Mandela co-founded the African National Congress Youth League (ANCYL), which focused on education and culture, trade union rights and the redistribution of land. Inspired by the ANCYL, in 1949, the ANC adopted the weapons of boycott, strike, civil disobedience and non-cooperation. The aim of the ANCYL was full citizenship and direct parliamentary representation for all South Africans.

During the ANC's Campaign for the Defiance of Unjust Laws in 1952, Mandela was elected National Volunteer-in-Chief of the campaign. His job was to travel around South Africa and organize resistance to discriminatory legislation. As deputy president of the ANC, he struggled against the violence and racism of apartheid.

Mandela wrote his bar exams and opened the first black law practice in South Africa. The government and law society attempted to deter his work but were unsuccessful. In 1960, the ANC and other liberation movements were banned. Following the massacre of peaceful black demonstrators in Sharpeville, Mandela went underground, and left the country to build support for the ANC. On his return to South Africa, he was arrested and later sentenced to life in prison at Robben Island Prison.

After being released from 27 years imprisonment, in 1990, Mandela plunged wholeheartedly into working to attain the goals that the ANC had set out almost four decades earlier. In 1991, at the first national conference of the ANC held inside South Africa since being banned, Mandela was elected President of the ANC, and his lifelong friend and colleague, Oliver Tambo, who had lived in exile for more than thirty years, became the organization's national chairperson. On May 10, 1994, in South Africa's first general election, Nelson Mandela was inaugurated State President of South Africa.

In a speech given to the Canadian government, in September 1998, Mandela said, "In order that the memory of historical injustice and violations of human rights should not remain as continuing obstacles to national unity, our Truth and Reconciliation Commission has helped us confront our terrible past. Painful and imperfect as the process has been, it has taken us further than anyone expected, towards a common understanding of our history."

Mandela, now retired, is renowned for leading the fight against apartheid and helping to establish a free, multiracial democracy in South Africa.

"We cannot waste our precious children. Not another one, not another day.
It is long past time to act on their behalf."

DR. EDGAR MITCHELL

Dr. Edgar Mitchell is a learner, teacher and explorer. After graduating from the Massachusetts Institute of Technology with a doctorate in aeronautics and astronautics, Mitchell became a NASA Apollo 14 astronaut, and was the sixth man to walk on the moon. He is also the founder, and now retired chair, of the Institute of Noetic Sciences.

On his way back to earth on the Apollo 14 lunar landing mission, in 1971, Edgar Mitchell experienced an epiphany: "I knew that the molecules of my body, of the spacecraft, and of everything around us were prototyped and initially created in some ancient generation of stars. That's standard science. But suddenly it was different. My knowledge wasn't just intellectual, it was, 'Wow, those were my molecules! What kind of mind is this that allows me to look at all this, to feel ecstasy and connectedness?'"

Questions raised by his euphoric experience, and a burning zeal to explain them in a new way, motivated Mitchell to establish the research organization, the Institute of Noetic Sciences in 1972. The core of the Institute's mandate is to explore ancient questions that every civilization has asked, such as: Who are we? How did we get here? Where are we going? Mitchell is particularly interested in the way that human consciousness, with its psychic and paranormal capabilities evolved. In the early 1970s, Mitchell worked with Uri Geller at the Stanford Research Institute, in California verifying Geller's psychic abilities, which include psychokinesis (the ability to mentally manipulate inanimate objects) and teleportation (the ability to transport an object using mental powers).

According to Mitchell, in the past five years, a mechanism in nature called the quantum hologram has been verified. It is at the base quantum level of matter. It has a property called non-locality, which is a basic finding within quantum physics. Mitchell explains that, "Matter, as we understand it, is local. We see it all around us. But scientists discovered that at a subatomic level, particles interact with each other and maintain a correlation wherever they go throughout the universe. That is called non-locality. It's been argued about because it's so far from our common thinking. Everything is supposed to be here and now and at a definite location. At the quantum level, that's just not so. Non-locality is to physical scientists what interconnectedness (or oneness) is to a mystic."

Laboratory experiments using this quantum mechanical theory include teleporting photons over 400 kilometers. Mitchell explains that "It's a statistical experiment. We're a long way from a macro-scale physical object, but we're on the right track…Everything that we started thirty years ago at the Institute of Noetic Sciences is becoming mainstream knowledge, with good scientific work, both theoretical and experimental, to back it up." Mitchell has written a paper called "Quantum Hologram: Nature's Mind," as well as a number of other papers that explain these concepts.

When asked if he believes in God, Mitchell said, "Not in the sense that most people do. All of our traditions speak of the God within, or the creative power within. That's what I focus on: the divine creative capability of our universe. I do not focus on the beingness of a grandfather deity somewhere, but on the process of intelligence and creativity that we find in the universe itself. The universe was not created all at once; it is still being created…Consciousness is not a thing, but a process…Trust in the process, that is the name of the game."

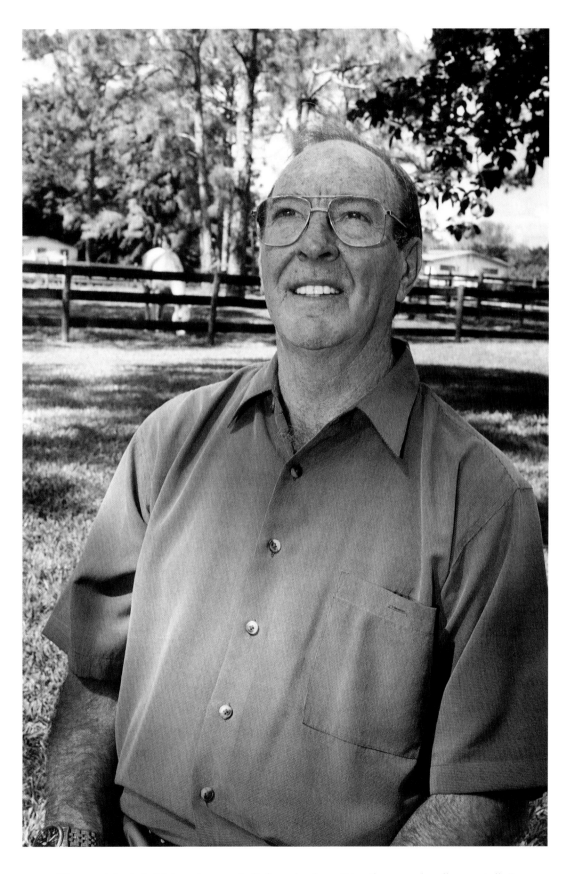

"Be consistent: hold true to your beliefs and values. Live them, and walk your talk."

ELIZABETH O'DONNELL

Former Ice Capades performer Elizabeth O'Donnell is the president and founder of the Skating Association for the Blind and Handicapped (SABAH). Since 1977, her not-for-profit organization has taught thousands of people who face physical, cognitive or emotional challenges, to skate for the pure joy of it. Volunteer-run and privately funded classes are held daily during the winter season and SABAH now offers training in the form of therapeutic ice seminars, to people with disabilities, their families, therapists and recreation specialists. An annual Ice Show Extravaganza held in Buffalo, New York, highlights and celebrates the accomplishments of the volunteers and challenged participants.

Elizabeth has been skating for over forty years. She toured with the Ice Capades after graduating from high school in the early 1970s. After that, she taught advanced skating at a figure skating club, and recreational skating at different town rinks. "Somewhere along the line, that situation became difficult for me – with the parents all wanting their daughters to be like Peggy Flemming, and talented youngsters sometimes being immensely competitive and kind of catty. I wasn't crazy about it."

When Elizabeth was eight or nine years old, she had a friend whose brother was non-verbal. "I got to know John...He had a system of gestures and sounds, which he used to communicate with his sister and parents. I asked my friend to teach me that system. That was when I first learned that communication could be different from the written word, a movie, or a conversation. At a very young age, that opened me up and taught me to have empathy for people who are different."

SABAH co-ordinates skating activities, seven days-a-week, at six local sites in Erie and Niagara counties in western New York and have recently added four national chapters in Pennsylvania, Ohio and and New York states. "Our skaters improve their balance, co-ordination, endurance and strength; they learn self-discipline; and they give meaning to our motto, 'I can do it, I can skate!'

Elizabeth and SABAH have received many community-based and national awards and honors, including being cited by former President George Bush Sr. as one of the nation's "points of light."

Elizabeth's advice to people is to "Find your passion and live it. The rest takes care of itself if you really find the passion that is in your heart and soul. You'll live the right life; you'll get congruent. You'll be a mentor, and you'll find someone to mentor you."

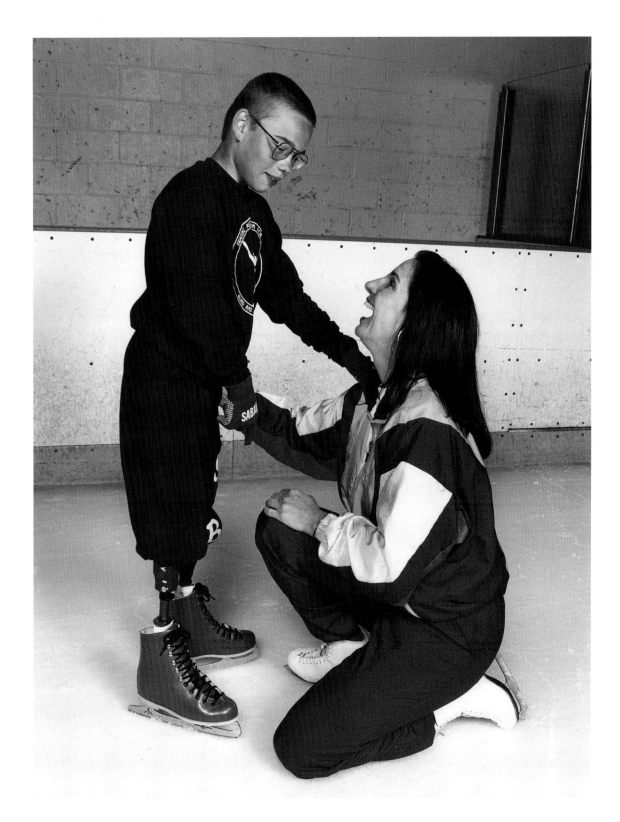

"Figure out what your values are, and then live them.
Examine them continually as part of your life process."

Alex Salamone and Elizabeth O'Donnell

MICHAEL O'NEAL

Michael O'Neal is a dedicated environmentalist. He is best known for bringing the non-sustainable clear-cut logging practices of lumber companies in northern California to the attention of the public and the Californian government. He was the lead plaintiff in a class-action lawsuit against the giant Pacific Lumber/Maxxam Corporation, which was successfully sued for $3.3 million, in March 2001. Corporate negligence caused a catastrophic landslide in his hometown of Stafford, in Humboldt County, California, which destroyed seven houses during a torrential rainstorm that lasted from December 31, 1996 to January 1, 1997.

O'Neal describes what happened when he awoke on the morning of December 31. "I woke up to what sounded like bombs going off above me. I rose to see what was up. Trees were snapping off and slamming to the ground. Shocked, I ran to where I could see clearly and spotted a tidal wave of mud and redwood trees heading straight for me and all the people living below me on the hill. I instantly thought of all the lives that were at stake. The debris flow was the width of a football field and about twenty-five feet high. Running just ahead of it, I managed to get everyone who was in immediate danger out of their homes. One third of our town was destroyed…We knew that over-logging on the very steep slope was the cause of the disaster."

This was not the first time Michael witnessed the effects of over-logging. As a young man, from 1973 to 1978, he planted over one million trees in many different mountain ranges from northern Mexico to Canada. "In my travels I couldn't help but notice that there was less and less forest and wildlife, mostly because of clear-cut logging."

Julia Butterfly Hill is another passionate environmentalist who has fought the clear-cut logging of old-growth redwoods. While Julia protested logging in the area known as the Headwater's Grove, Mike worked closely with her on publicity. He set up a radio-powered telephone system, so that Julia could communicate from her redwood, "Luna," with the rest of the world about their protest.

Michael's passion for nature was an integral part of his growing up. His grandparents, Charles and Dorothy Young, were renowned botanists, who inspired Michael at an early age. John Muir, the first president of the Sierra Club, an American naturalist, explorer and writer, and an influential conservationist who worked to preserve wilderness and wildlife from commercial exploitation was also a role model. Michael cites Richard Gienger, an environmental activist affiliated with the Environmental Protection Information Center (EPIC), as a contemporary mentor. EPIC is a not-for-profit organization actively involved in protecting California's ancient redwood ecosystem through public education, citizen advocacy and litigation.

Michael O'Neal would like it if people could do random acts of kindness for each other. "People need to spend a little more time studying the delicate planet that we live on. If there is an opportunity to make a change, don't hesitate to get involved. Do something that is going to help the future of this planet."

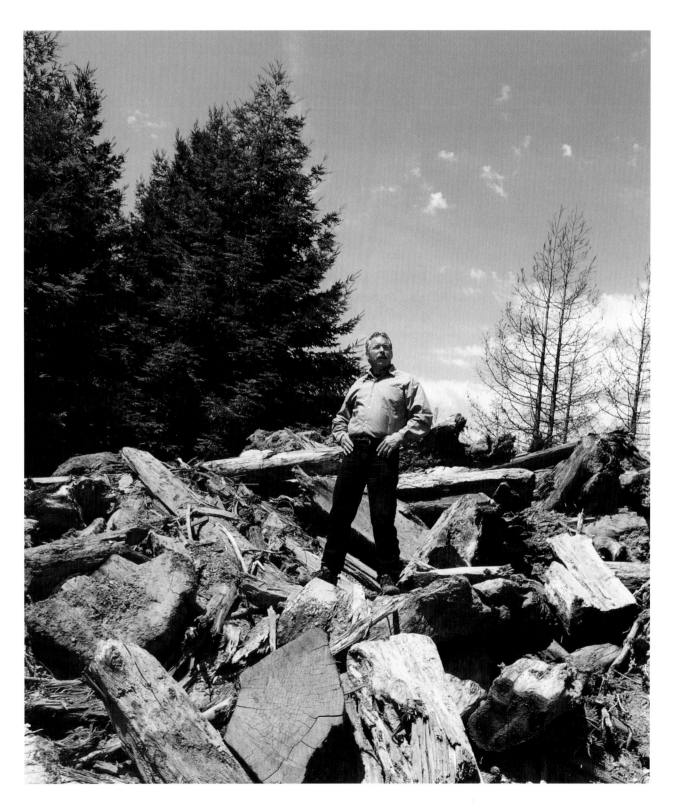

"Integrity is keeping your word."

DR. NANCY OLIVIERI

Dr. Nancy Olivieri experienced an ethical dilemma that many medical researchers find themselves in today. As a professor of pediatrics and medicine in Toronto, Ontario, Dr. Olivieri was involved in testing the drug deferiprone to treat the disease Thalassemia [inherited form of anemia]. After Dr. Olivieri concluded that the drug caused dangerously high blood-iron levels, and that long-term use could lead to permanent liver scarring and failure, and possible death, she spoke out publicly and had her findings published in a number of medical journals, including the reputable *New England Journal of Medicine* (August 1998). After Dr. Olivieri exposed the possible side effects of the drug, the pharmaceutical company that she was conducting research for, canceled her research project and sued her for breach of confidentiality.

Olivieri's employer did not protect her interests or those of the children being tested. The hospital was expecting a $30 million funding grant from the drug company, which put them in a conflict of interest position regarding research outcomes. During this experience, Dr. Olivieri believes that she came face-to-face with evil. "There are many people who I would describe as completely evil. They have ignored the small guy, the child, and have said that money is more important."

To support the ongoing struggle of Dr. Olivieri and others in similar situations, Doctors for Research Integrity was founded. It is a non-profit group of over 200 doctors, scientists and citizens, who seek to improve biomedical research standards, and promote research integrity and the right of scientists to publish negative data that point to potential dangers for patients. Olivieri's brave stance has brought the relationship between government regulating bodies, medical and educational institutions, and pharmaceuticals under harsh scrutiny.

Dr. Olivieri's main message for people is that "Personal honor matters…Patient protection cannot be compromised."

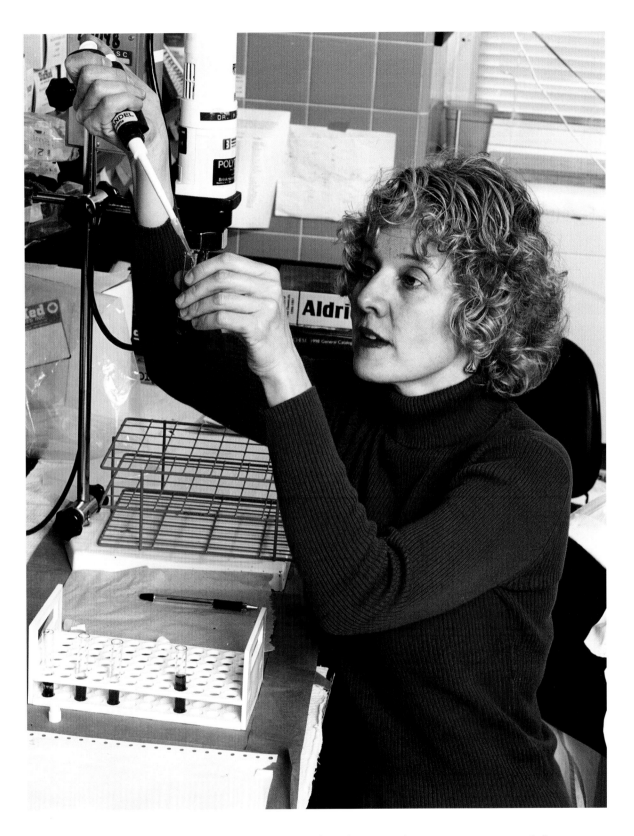

"Integrity is doing the right thing, even when there are adverse consequences to it."

SHIMON PERES

Shimon Peres has had a full and rich public life as an Israeli Labor Party politician, and has served three terms as Prime Minister of Israel. Peres has been involved in politics since 1947 when, as a member of his kibbutz, he was called upon to help establish Israel as an independent Jewish state. In 1994, he was awarded the Nobel Peace Prize, for his role as a key negotiator in the Middle East peace process, along with then Israeli Prime Minister Yitzhak Rabin and Palestinian Liberation Organization Chairman Yasser Arafat. Today, as Israel's Foreign Minister, Peres continues to broker peace with the Palestinians.

Shimon Peres worked closely with David Ben-Gurion (1886-1973), statesman and former prime minister of Israel, and considers him as a mentor and the greatest Jew of all times. "I learned a great deal from him about integrity, honesty, courage and patience...Above all I learned that moral values should be the key consideration when seeking to reach a wise decision. This belief was inspired by the vision of the Old Testament prophet Amos – to achieve social and economic equality among peoples and the precepts of the prophet Isaiah – to make peace among peoples, consequently bringing peace to the world...My top dream is to achieve full peace in the Middle East."

Peres believes that there is a revolution occurring within humankind. "Until now, history has been written in red ink; the story was one of war, blood and confrontation. Perhaps people had to go to war to defend their land. But today with modern science and technology, there are forms of strength and wealth that are not just material. With science and technology, we don't need borders, and we don't need wars. I cannot say that there will be no war, but I can say is there is no need for it."

Shimon Peres has one daughter, two sons and six grandchildren. His advice for parents raising children is, "Let them go. The best you can do is to serve as an example, never as a dictator. Let your children enjoy real freedom from the first day of their life. Don't impose yourself on them. Be fair and honest with them. Let them be independent, provided they are honest and hardworking. Tell them that to study is the greatest thing in life, and teach them that imagining is just as important as remembering." Peres sees this kind of upbringing as a prerequisite for living a full life.

In 1997, Peres founded the Peres Center for Peace, a nonpartisan, nongovernmental organization dedicated to promoting peace in the Middle East. The Center's mission is: To build an infrastructure of peace by and for the people of the Middle East that promotes socio-economic development, while advancing co-operation and mutual understanding. "I would like to see everybody taking a pen and putting in it a fountain of green ink, to write about a world of hope and beauty."

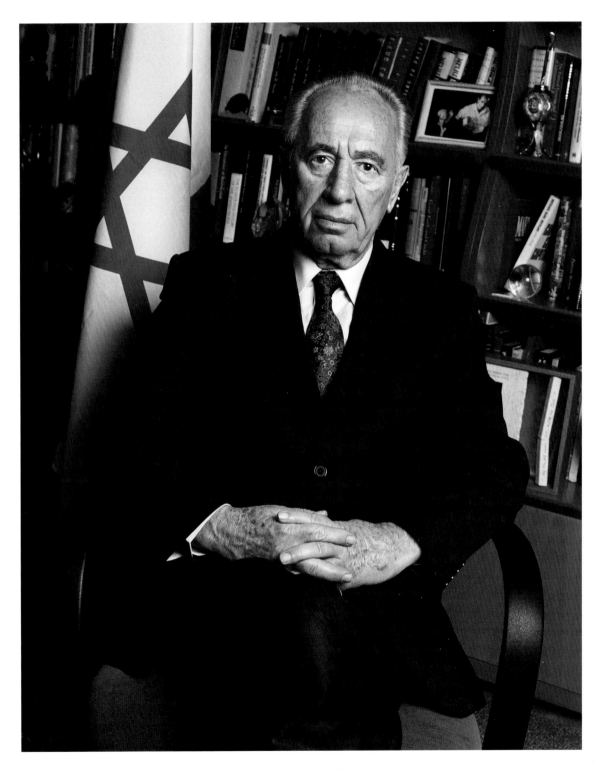

"Be guided by high standards of moral values and ethical behaviour, rather than be swayed
by narrow self-gratifying considerations. Abiding to this principle will empower us
to act on the strength of our convictions."

KIM PHUC

The black and white photograph of a naked, screaming nine-year-old Vietnamese girl running towards us, has become an icon of the Vietnam War. Kim Phuc, now living near Toronto, Ontario, has a smile that barely reveals the trauma she suffered as a result of the napalm burns she received when her village was bombed on June 8, 1972. On that day, after being alerted that the temple where she and her family were hiding was going to be hit, they had run outside and were then bombed by South Vietnamese air force planes.

Kim recalls the horrific event: "It was in summertime. The very light clothes I had on instantly disappeared, and my body caught fire. I was so scared, I kept running and running until I had to stop from exhaustion. One of the soldiers gave me some water to drink. I was screaming, 'Too hot! Too hot!' Trying to help, he poured water over my body. But the napalm burned under my skin, so pouring water on it just made it worse. To give you an idea of how hot it was: the temperature of boiling water is 100 degrees Celsius, and napalm is 800 to 1200 degrees Celsius."

After taking the photograph, Nick Ut took Kim to the hospital where she was hospitalized for fourteen months and received seventeen operations to repair the third-degree burns all over her body. Kim still suffers pain as a result of the injuries.

Since becoming a practicing Christian, Phuc's faith in love and forgiveness has acted as an antidote to her painful experience. She works towards putting an end to the pain and suffering of children who experience the effects of war. The Kim Foundation, which she established in Canada and the United States, provides aid to children in war-torn countries. East Timor is currently an area of focus. The Foundation supports projects that provide prosthetic and orthopedic devices, wheelchairs and rehabilitative services to children in need and channels funding to organizations that service disabled children and children who are affected by war around the world.

As a UNESCO Goodwill Ambassador for the culture of peace, Phuc travels extensively, sharing her story with church groups, at conferences and at educational institutions. Her favorite audience is students. "I know some schools where they are shooting students...We don't need that violence. Everybody needs to do their best to stop war and violence, and promote peace."

Kim has two young sons. As a mother and a person who has grown through a tragic experience, she believes that children should be "raised with a solid foundation of

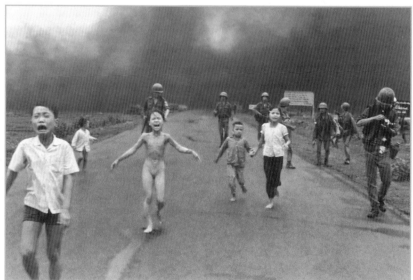

Nick Ut, Associated Press, June 8, 1972

love, taught to love God, love one another, and do good." Phuc's purpose in life is to glorify God, show love and help people. This is her way of finding peace.

Kim's message for people around the world is: "We should love one another by helping, sharing, understanding, respecting and forgiving. We don't need war. We don't need hatred. We don't need violence. These things destroy us, generation after generation."

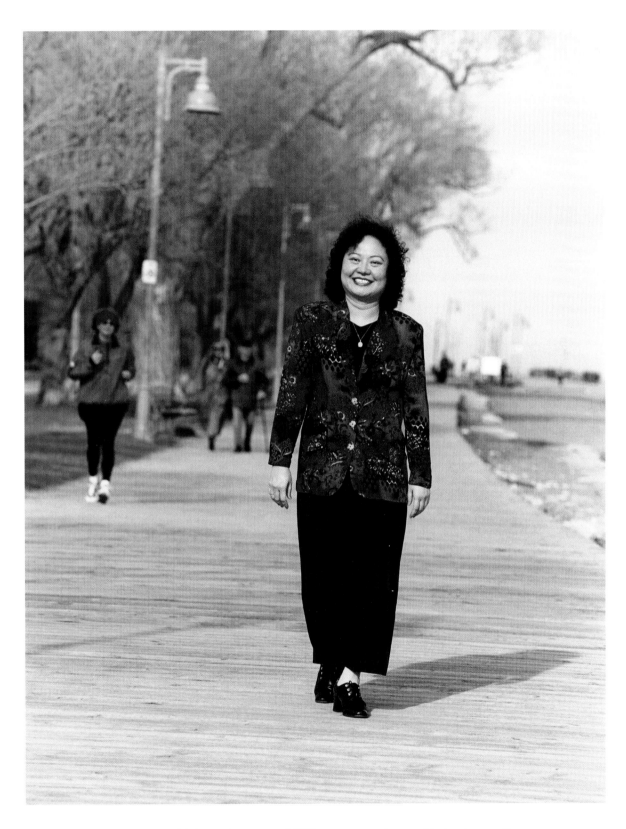

"Living with integrity means fulfilling our promises and being honest."

BONNIE RAITT

Bonnie Raitt is a singer, songwriter and guitarist whose unique style blends rhythm and blues, rock and pop. After twenty years as a cult favorite, she made it to the top of the charts in the early 1990s, with her Grammy award-winning albums, Nick of Time and Luck of the Draw, which feature hits like "Something to Talk About" and "I Can't Make You Love Me." Bonnie has accumulated nine Grammy awards to date, and in March 2000, she was inducted into the Rock and Roll Hall of Fame.

A Los Angeles native, Bonnie Raitt comes from a musical and socially conscious family. Her father, John Raitt, was a Broadway star, and her mother Marjorie, an accomplished pianist and singer. Bonnie began playing guitar when she was eight years old, inspired by counselors at summer camp, and was later influenced by the folk and blues music revival that swept across college campuses in the 1950s and 1960s.

Bonnie's greatest influences are her circle of friends who are both musicians and activists: "Joan Baez was one of the strongest influences on my early love of the guitar and folk songs. Like my family, she was a Quaker and pacifist, which led her to fight for civil rights and peace. Her activism was and continues to be a great inspiration to me. My brother in social causes and in music, since we first became friends in 1970s, is Jackson Browne. His brilliant artistry, integrity and passionate activism have been a model for my own life and music." Raitt also draws inspiration from her family; from activists like Martin Luther King Jr., Mahatma Gandhi and Nelson Mandela; and from a long list of musicians including Aretha Franklin, Bob Dylan, Ruth Brown, Charles Brown, Mississippi Fred McDowell, Son House, Muddy Waters, John Lee Hooker, Sippie Wallace, Dick Waterman and Pete Seeger.

When asked to what she attributes her success, Bonnie said, "More than anything else, I think perseverance and sticking to what I truly believe is right have helped me get me where I am. Of course, luck and opportunity have played a huge part as well. In 1971, when I was in college, I was offered the opportunity to record for Warner Brothers Records. I told them that if they agreed to never tell me when, what and with whom to record, I'd sign with them. I never expected them to agree. When they did, basically giving me complete artistic control, it set a course for my own self-determination from which I have yet to veer."

In addition to being a celebrated musician, Bonnie is an avid social and environmental activist. In 1988, she became a founding trustee of the Rhythm and Blues Foundation, which fosters wider recognition of R&B music and financial support for artists who have not received adequate compensation for their music. In 1995, Bonnie initiated The Bonnie Raitt Fender Guitar Project, with the Boys and Girls Clubs of America, to develop music education programs and encourage inner-city girls to learn to play guitar. Bonnie performs many concerts for causes close to her heart, such as nuclear disarmament, the fight against the dumping of nuclear waste on Native American lands, the protection of ancient growth forests, and women's reproductive freedom.

A fearless warrior for human rights, Raitt believes that "Ageism is one of the greatest tragedies of modern times. There is so much to be learned from our elders. The miracle that unfolds, as we become wiser and more awake, is one of the greatest gifts of aging. Maintaining a sense of humor about the ways our bodies crumble is imperative. It's all the more reason to keep exercising, watch what we eat and think, and keep as much positivism and love in our life as possible.. As for my generation, I don't think we'll be going quietly into the dark night. I plan to keep rocking and growing until I drop, which hopefully won't be for a long time."

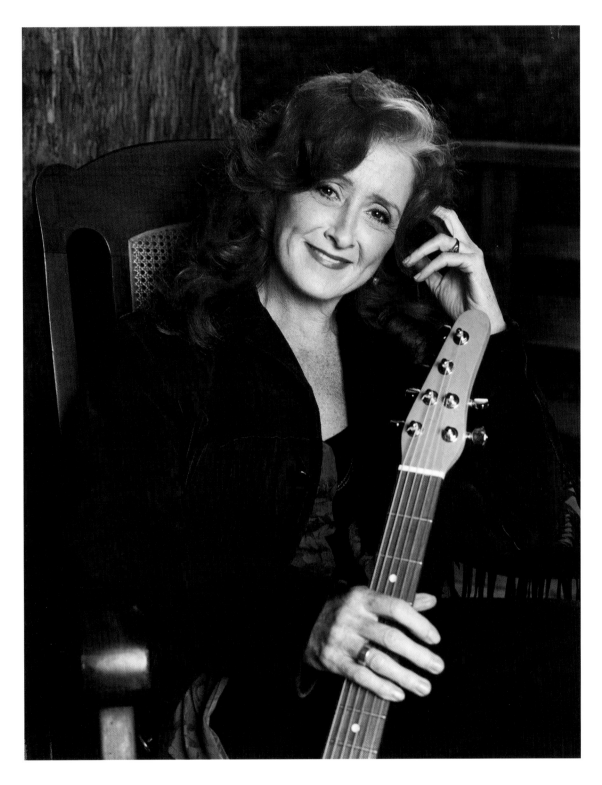

"Integrity means being true to yourself and doing what you believe is right...coming from a place where you make decisions based on the highest good, and don't compromise for the sake of convenience. It means taking the higher ground."

NORBERT REINHART

Norbert Reinhart, the owner of the Canadian-based geological exploration company called Terramundo Drilling, volunteered to be held hostage by the Revolutionary Armed Forces of Columbia (FARC), in exchange for the freedom of one of his employees. In June 1998, the ransom-seeking rebels had kidnapped fifty-eight-year-old Canadian, Edward Leonard. When after 106 days, the ransom negotiations with the guerillas were not progressing, Reinhart and convinced them to release his drill foreman, in exchange for his own captivity.

Upon meeting his employee for the first time, Reinhart said to Leonard, "Your shift is over, you can go home now." Leonard filled him in on a few practical issues regarding his captives, namely that they liked to play cards, that they were friendly, young and uneducated. But he told Reinhart not to misjudge their youth because they could kill him in a minute.

Reinhart's Terramundo Drilling had been contracted by Grey Star Resources to conduct exploratory drilling in a rebel-controlled area near Bucaramanga, in northeast Columbia, where there had been other kidnappings in the past. Reinhart spent ninety-six days as a prisoner of the FARC. He relayed that he was never treated violently, and when they tied him up, they said to him, "Don't be alarmed, this is just a security measure." They tried to alleviate any physical and mental pressures he had.

Meanwhile, Amnesty International, the Red Cross and his family put pressure on the Colombian and Canadian governments. In the end, Reinhart paid $130,000 CDN for his own release. "I knew I was paying a ransom that might be used to buy guns to shoot people. I knew I was giving these people that tool in exchange for Ed's life and freedom, and later my own. How much destruction have I brought to other people with that ransom money? That's a tough moral question."

Since surviving the ordeal, Reinhart finds joy in the small pleasures of life: "Interacting with the environment and people are the real joys of life. It is a tremendous privilege to be able to see and experience a sunset, a fresh breeze, a good meal." His advice to people is "to take time to smell the roses."

"Integrity is doing what is right, regardless of the consequences."

JOHN ROBBINS

John Robbins is the celebrated author of *Diet for a New America* and *The Food Revolution*. John also founded EarthSave International in 1988, a non-profit organization that promotes food choices that are healthy for people and this planet.

In the 1960s John Robbins was a student at Berkeley University and a follower of peace activist Martin Luther King. When King was assassinated in 1968, this marked a turning point in John's life. That same year, Burt Baskin, John's "Uncle Burt" died of a heart attack. John had to decide if he wanted to take over the Baskin-Robbins ice cream business. John had been groomed by his father to take over the company. "I loved ice cream. I knew that the four basic food groups were chocolate, vanilla, strawberry and mocha almond fudge." Although John respected his father and admired his business acumen, this was not the direction that John wished to take. He comments, "As I matured, I didn't feel that adding a thirty-second flavor was an adequate response to the challenges of our time."

As John puts it, "I chose integrity over money." John's wife and partner, Deo, supported his life-altering decision to follow another path and reject the wealth that could have been achieved through the family ice-cream business.

The couple moved to remote British Columbia, Canada, where they lived for a decade. John recounts, "I had a bout with polio as a child. When I was twenty-one, my left leg was three inches shorter than my right, and pretty weak. The doctors said, 'You're going to have to get used to this, your growing years are over.' Western medicine treats the body like a machine, not realizing that the body is a miracle. When I changed my life and stopped trying to live up to my parents' expectations, but instead tried to listen to the dictates of my higher self, I changed the way I ate, and started eating natural healthy whole foods. I began practicing Hatha yoga, meditating and praying more, and my leg grew. Now it's as long as the other one. I became a marathon runner, a tri-athelete and a dancer."

In British Columbia, John taught yoga, organized meditation retreats, and gave workshops and seminars on personal growth. He studied nutrition and environmental issues and completed a post-graduate degree. The information and experience that John garnered during this time inspired him to write the best-selling, Pulitzer Prize-nominated *Diet for a New America: How Your Food Choices Affect Your Health, Happiness and the Future of Life on Earth.*

John's advice to people is to "Live in alignment with your central purpose and deepest values, whatever these may be for you."

"The simplest definition of integrity is walking your talk so that your life is a statement of what you believe in. Integrity comes quite naturally when you are committed to something that has a value above and beyond your own personal desire."

John and his wife, Deo.

CHRIS ROBERTSON

During a ten-month period in 1998, Chris Robertson bicycled 6,520 kilometers (4,000 miles), as an act of Canadian patriotism. He was the first person to travel on his own power from Point Pelee in Southern Ontario, through the prairies to British Columbia, and then north to Tuktoyaktuk in the Canadian Arctic. He was spurred by the threat of Quebec independence that had been highlighted by the 1995 Quebec sovereignty referendum. His 1998 expedition is documented in his diary-style book, *To The Top Canada*.

After a trip to Montreal to attend a rally in support of Canadian unity, just before the Quebec referendum, Chris returned to his native Hamilton, Ontario, with a need to do something concrete to express his strong federalist convictions. He wanted to do something that had not been done before, something that relayed his patriotic feelings to other Canadians.

Chris Robertson cashed in over $37,000 of his RRSPs to cover his family's living expenses while he traveled on his bike from the southernmost point of the Canadian mainland to Tuktoyaktuk. He brought a tent, a sleeping bag, a pager and a hand-held global positioning system with him on the trek.

What kept him going along the way was a deeply felt love for his wife and son, passionate patriotism and his Christian faith. Robertson, a professional public speaker, stopped in fifty-one communities, and gave speeches on the subject of national unity, and he challenged individuals to make Canada a better country. One of his suggestions was that every family should make it a goal to visit every region of Canada. Robertson received a warm welcome from people in the cities and towns he visited, and his trip and message were well-received. "I was born a Canadian, and I've always been proud of Canada. I've had the privilege of visiting different parts of the world, and the more that I see, the more proud I am of our country."

Chris Robertson has the following advice for people: "If you know where you want to go, just keep going and one day you'll arrive. That was very much my philosophy throughout the "To The Top Canada" expedition. Any destination is achievable; you just have to keep pedaling every day."

"My definition of integrity is twofold: one, it's the desire to do good in all your actions; two, it's consistency in what you say and what you do. When you do good and are consistent, the by-product of that is trust."

DR. ROBERT SCHULLER

Dr. Robert Schuller is a pastor, motivational speaker and author. He is renowned for his ministry, which is located in the Crystal Cathedral, in Garden Grove, California. Schuller's syndicated "Hour of Power" television show, which is taped in the Crystal Cathedral, is the most watched religious program in the United States and reaches nearly 30 million viewers in more than 184 countries.

Of the many personal setbacks Schuller has survived, including two brain surgeries, a heart attack and numerous accidents in his immediate family, the one he remembers most is the tornado that leveled his childhood farm home in Iowa. "I'll never forget my father's response. He told me to look at what we had left and not to look at what was lost. He taught me then that life is full of choices, and in times of setbacks, you can choose to be bitter or you can choose to be better. I try to be a better person with each setback that I experience…Facing adversity is an opportunity to put your faith into action, to create new friends, to explore untapped possibilities, to build your character, to be positive amidst trial, to present a positive message of hope to a hurting world. The benefit of facing adversity is similar to the tempering of steel: steel is heated and cooled, and is strengthened in the process."

Robert was called to the ministry when he was just four years old. His Uncle Henry, a missionary in China, prophesied his calling and taught him that meeting people's needs was putting God's work into practice. That became the mission of Schuller's ministry: "to find a need and fill it, to find a hurt and heal it."

Robert Schuller was ordained in 1950 by the Reformed Church in America and pastored in Chicago for five years before being called to start up a new church in California. With his wife Arvella as organist, and $500, he rented the Orange Drive-in Theatre and conducted worship services from the roof of the snack bar. This later inspired the open-concept Crystal Cathedral, designed by New York architect Philip Johnson.

Schuller oversees an evangelical empire, which includes preaching schools and a counseling center. He is internationally sought after as a motivational speaker, especially for his ideas about goal-setting. Dr. Schuller is the author of more than thirty inspirational books, five of which have been on the New York Times Publisher's weekly bestseller list. His autobiography is due for publication in the fall of 2001.

Dr. Schuller reflects: "The purpose of life is to live in such a way as to reflect Christ's love in what I do and how I do it, in what I say and how I say it, and to be His voice, His ears and His touch to all the people I come in contact with."

"Integrity is being nonduplicitous and honest in adhering to my beliefs. It's not taking the easy way out when the right way is tougher. It's doing the right thing when no one is watching, when I might get away with compromising my beliefs."

ALAN ROY SCOTT

A professional songwriter and music producer, Alan Roy Scott uses music as a cultural and political bridge builder. "Music Bridges Around the World" is an organization he established to bring songwriters, artists and musicians from different cultures together. It sets up a congenial and creative environment where artists can write songs and perform together. In March 1999, he initiated a goodwill cultural exchange between Cuba and the United States, which allowed over 70 American and Cuban musicians to write songs and perform together – what Scott describes as the 'Musical Peace Corps'.

Alan grew up on the south side of Chicago, in the heart of the American mid-west. He acknowledges his father, a businessman and local civil rights leader in the 1960s, as a great personal inspiration and role model. "I grew up in an atmosphere of tolerance.. Once I found that music was my chosen vehicle for promoting my personal beliefs, I followed that trail and started to make a living writing music." In the 1980s Alan represented the United States at international music festivals, and in competitions as a composer and artist. He traveled to various countries such as Japan, Ireland, Kazakhstan, Poland, Lithuania and Cuba. These trips reinforced what Scott had learned from his father about the equality of people.

While growing up, Scott was influenced by many political figures who have made a difference in the world, namely: Martin Luther King, Mahatma Gandhi and Nelson Mandela. He was inspired by the music of Earth, Wind and Fire, The Beatles, Stevie Wonder, Mozart, Gilbert and Sullivan, and musical artists such as Bob Geldoff who has organized international benefit concerts such as "Live Aid" and Sarah McLachlan, the talent behind "Lillith Fair" which showcases women artists.

In 1988 the first Music Bridges Around the World events took place in Finland and the USSR (Russia) in Helsinki, Moscow, Tallinn, and St. Petersburg. More recent projects have taken place in Romania, Indonesian, Cuba, and in Germany during Expo 2000. The concept of Music Bridges is to "bring together a group of really talented, wonderful, mostly famous people who have gotten caught up in the music and career machine, and put them back in touch with the basics of making music out of love, by working with similar-minded people from different cultures..

It's very rejuvenating both musically and spiritually.. It's like camp!" Participants (over 200 to date) have included Bonnie Raitt, Cindy Lauper, Peter Buck (R.E.M), Michael Bolton, Burt Bacharach, and Jimmy Buffett working with artists from other nations like Chuco Valdez and Carlos Varela from Cuba, Paddy Maloney (Chieftans) and Jimmy McCarthy from Ireland, and Alexander Gradsky and Andrei Makareivitch from Russia."

Scott's Music Bridges facilitates personal and intercultural connections. He explains, "If you and I write a song together, we get to know each other. It's show and tell; we talk about lyrics, music, the world, your mother, my mother and your sister. We come to realize that whatever countries we come from, and whatever languages we speak, we all have the same experiences." After the song writing is finished, a final concert featuring these new songs, or what Scott prefers to call "an experiment," is presented. He sees the process as more important than the finished product.

A good example of this would be during Scott's Music Bridges in Germany during Expo 2000, when through a lottery process, the first names drawn to work together were Baruch Friedland from Israel and Gaby Farah from Lebanon. This happened in October 2000, against a backdrop or renewed violence in the Middle East. Consequently, "in the true spirit of music and brother/sisterhood they agreed to try it. They had disagreements and fights about the creative process and some more tense moments discussing politics, but wrote, recorded, and performed two beautiful songs together as musical ambassadors of nations in conflict. They represented everything that is possible through music that isn't always possible by other means."

Scott sees himself as a "mini-messenger of God." He describes his faith as "the religion of believing we are all one.. I draw the line when a religion starts saying, 'We are the only way,' whether it's orthodox Judaism, Islamic fundamentalism, Protestantism or any other 'ism'.. That's the kind of thing that leads to murders in Ireland, Bosnia or the Middle East." Scott works towards building a world of peace and love through his musical projects. His message to people is to "be part of the fabric of goodness that we need to keep weaving in the world."

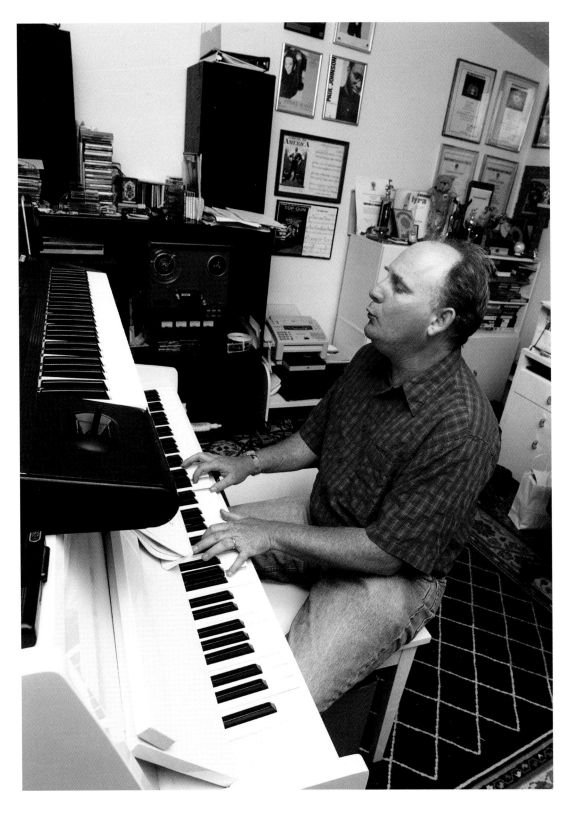

"Integrity means doing what you say you're going to do, against all odds."

MARTIN SHEEN

Martin Sheen is a familiar face on NBC's prime-time political drama series, "The West Wing," in which he stars as the President of the United States. Sheen uses his celebrity status as a Hollywood actor to draw attention to a range of political and environmental issues, such as: nuclear weapons testing and the arms race, the military training of Latin American troops and mercenaries at the US Army School of the Americas in Fort Benning, Georgia, and most recently, seal hunting off the Magdalene islands in the Gulf of the St. Lawrence. "I've tried to focus on issues that are particularly important in our culture, and draw people's attention to them. These diverse concerns are all within the realm of social justice. The destruction of the environment, poverty and homelessness are all about injustice."

Martin Sheen, was born Ramon Estavez in Dayton Ohio, in 1940, and is the seventh of ten children of Irish and Spanish immigrant parents. He was raised primarily by his widowed father, who was a factory worker at the National Cash Register Company. Between the ages of nine and eighteen, Martin worked as a golf caddy. "This was a very important part of my formation because I saw a lot of very well-to-do people behaving very badly. It left an indelible mark on me. I'm grateful for the experience because it made me understand what I didn't want to be...The reason I love Tiger Woods so much is that he plays tournaments at clubs that he couldn't belong to, and he beats the dickens out of his opponents! He beats them like a rug!"

On March 5, 1977, while working on the movie "Apocalypse Now" in the Philippines, Martin Sheen suffered a heart attack. "That was a wake-up call. If you survive illness and misfortune, it can really change your life because it changes your priorities and puts you more deeply in touch with your humanity...Life is a precious gift. Hang on to it! Celebrate it because it can disappear."

For Sheen, spirituality and humanity are intertwined. "If spirituality is something different from humanity then I'm not interested in it. I think that to be spiritual, you have to be human. That's the genius of the image of God in our culture. God becomes human; He becomes flesh and blood, and dwells within us."

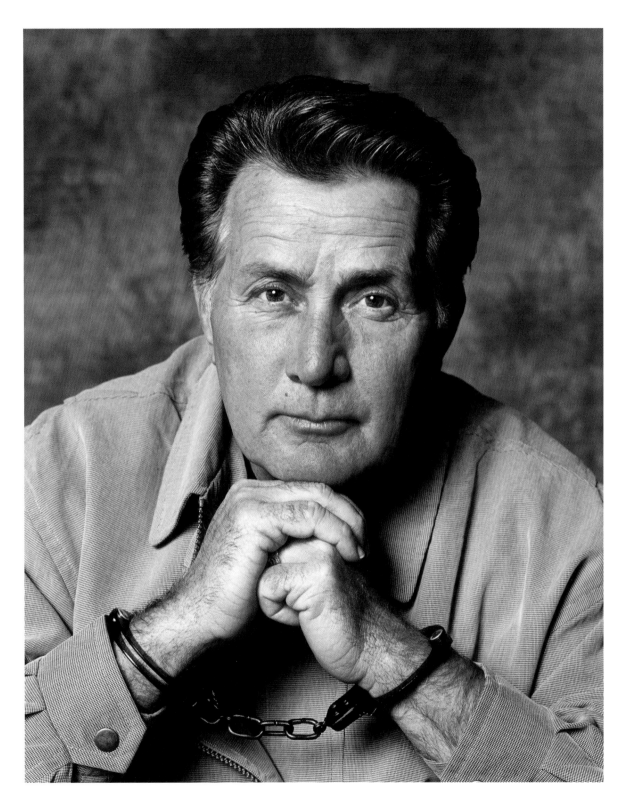

"For me, integrity means daring to risk who you are and where you come from, for an ideal.
It's got to cost you something; it doesn't come cheap. I think that anything in life that's heroic – and
integrity is certainly an aspect of heroism – is very expensive."

DUNCAN SHEIK

Folk/pop singer and songwriter Duncan Sheik believes that universal joy is attainable if we all take responsibility for our actions. Sheik comments, "You're very much aware that there are people who are suffering. You've got two choices: one, you can passively accept the state of things and say, 'Yeah, that's a drag,' or you can live your life in such a way that you try to turn things around, in whatever small or big way you can. If you can do the second, then right away, your whole attitude and feeling about life will change. You'll have hope at that point."

Duncan Sheik's recording career began with his self-titled album, produced in 1996, followed by the intricately symphonic "Humming" in 1998, and most recently, "Phantom Moon" which sets lyrics by Steven Sater to his own acoustic music, was released in 2001.

His work has developed from lovelorn self-absorption into more socially aware material. A Buddhist and political pacifist, Duncan advocates for greater government support of the arts. He is also involved with several not-for-profit organizations, including Music Bridges Around the World, which sponsored musical collaborations with Cuban musicians; and Future Trust/War Child U.S.A., which sponsored three concerts in 1999 to benefit Kosovar Albanian children in refugee camps.

Duncan Sheik's spiritual practice has influenced his musical work. His beliefs inspire both the content and presentation of his music. "In Buddhism, as with most Eastern traditions, there's a sense that God, or Buddha, or whatever you want to call it…is your own life. It is nothing other than your own life, and all life. That's the idea of the oneness, the connection of everything in the universe…It is possible to be extremely joyful in this life, no matter what your circumstances are. I think the clue to finding joy has a lot to do with understanding that "what you get is what you give;" that you have the perfect Buddha nature within you. If you can develop that understanding into a belief in yourself, then life can be a really great thing."

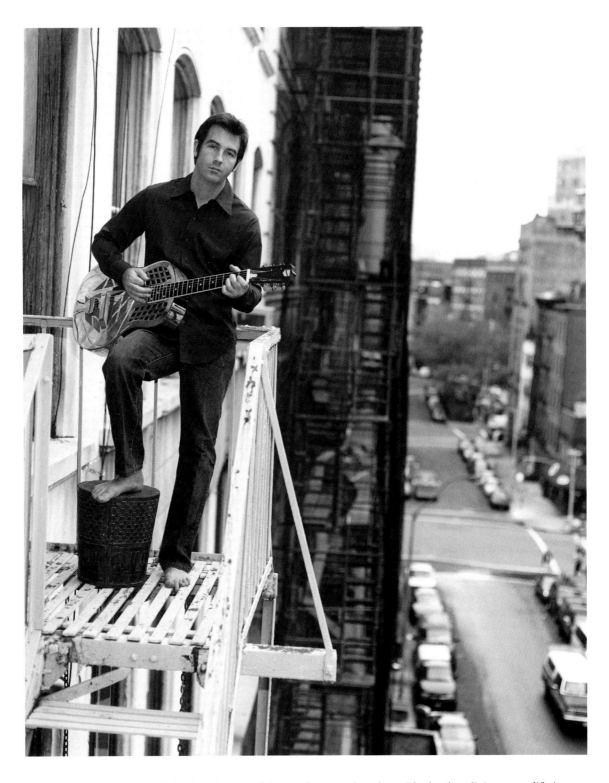

"For me, integrity is believing in something and expressing those ideals, then living your life in accordance with what you believe and what you say. It's a consistency of character."

DR. JEFFREY WIGAND

Dr. Jeffrey Wigand, a former senior tobacco industry executive, now active as an educator and head of "Smoke Free Kids" is renowned for his groundbreaking work confronting tobacco companies about their flagrant disregard for public health and safety. Wigand became a hero and media celebrity by standing up to the tobacco tycoons who refused to acknowledge the health hazards of tobacco use. Most people are familiar with Wigand's story, which was told on the CBS television show "60 Minutes" (1996) and in the movie "The Insider" (1999).

As vice-president of research and development at Brown & Williamson, from 1989 to 1993, Wigand became familiar with the company mantra of denying the addictive and dangerous properties of tobacco use to the public. "I realized after ten months with the company that I had made a mistake. I was making a lot of money. I had a wife, and two daughters, one of who required extensive medical coverage, and I wasn't ready at that time to bring the wrath of the tobacco industry on my family and me. So I looked the other way until laboratory testing showed a controversial pipe tobacco additive, called Coumarin, to be a lung-specific carcinogen in mice and rats..." As a result of his taking issue with the continued use of Coumarin in pipe tobacco, Jeffrey Wigand was terminated from Brown & Williamson in 1993.

In 1994, the CEOs of seven major tobacco companies swore before congress that nicotine was not addictive. At this point, Wigand had an epiphany. He decided to help the Food and Drug Administration (FDA) navigate through the confusing science and documents. This gave the FDA the information they needed to regulate tobacco and to establish rules that would govern cigarette access. Tobacco companies are now under an avalanche of worldwide lawsuits from individuals, governments and third party health-care providers, seeking compensation for tobacco-related illnesses.

Wigand became a public figure because he was willing to break a confidentiality agreement with his former employers and tell the truth about the adverse health effects of nicotine, additives and smoking in general. He appeared on "60 Minutes" with Mike Wallace in 1996, and talked about the smoking issues, and how his family was being harassed with death threats. Personal fall-out from the stress included a divorce from his wife that same year. Brown & Williamson sued Wigand for breach of confidentiality when he spoke out against the dangers of smoking. They finally dropped their case on June 20, 1997, as a result of a settlement between states' Attorneys General and the tobacco industry.

Today, Dr. Wigand teaches children about the harmful effects of tobacco use as head of a non-profit organization based in Charleston, South Carolina called "Smoke-Free Kids". According to Wigand, the tobacco industry needs to get 3,000 children a day, roughly one million kids a year in the U.S.A. alone, to keep the business going. His aim is to counter the effects of their unethical business practice of targeting the world's children.

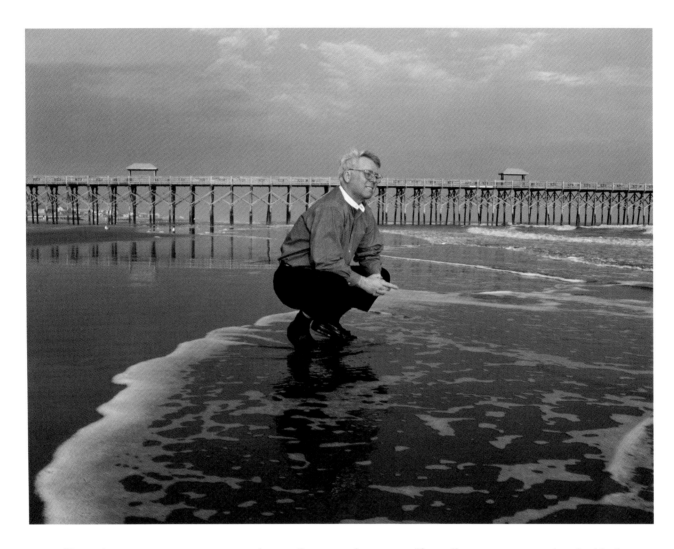

"Integrity encompasses many complex attributes, such as a steadfast adherence to a moral and ethical code, which is characterized by honesty, honor, moral strength, respect, consideration for and protection of others. In a speech to the Massachusetts State Legislature in 1961, John F. Kennedy captured it most eloquently when he said that one of the four questions we will be asked by the high court of history, as it sits in judgement of each of us, is: 'Are we truly men of courage, judgement, integrity and dedication?' I hope I can say 'yes' to each of these, especially integrity."

PHOTOGRAPHER'S COMMENTS

DR. MAYA ANGELOU Photographed at home in Winston-Salem, North Carolina. Dr. Angelou speaks with a voice that comes deep from within her soul. Having surmounted great adversity in her life, she spoke with a feeling of knowing where she came from, and how she created her life. The day of our meeting was a very hectic one for her, so my time alloted for the portrait and inteview was shorter than planned. As I was preparing to leave, her powerful voice boomed from the kitchen. "Mr. Shainbaum! Next time you are back in town, give me a call. I want to cook you dinner." I gratefully said that I would take her up on her gracious offer. Web-site: www.mayaangelou.com

EDWARD ASNER Photographed in his office in Los Angeles, California. Walking in to Mr. Asner's office was like walking into a museum. The walls were covered with masks, and shells, butterflies, photographs, etc. There was so much history and science there. I asked him what he would do for work if he wasn't an actor. He replied, "I'd be an archeologist." Throughout the shoot his voice shook with emotion. Ed feels deeply for people, especially the underdog. He knows how difficult it can be to challenge the power brokers in society.

LUCAS BENITEZ Photographed during the protest march to Orlando, Florida. It was an extremely hot day when I flew down to Florida. It was one of my most challenging shoots as while I was photographing Lucas during the march, I would drive past the marchers by a block or two, then set up with my telephoto zoom lens as they approached. I repeated this sequence over and over again but the sun would always be in the wrong direction, or the shadows from their hats would obscure their faces. I was impressed by Lucas' strong social consciousness. He is a young man who has dedicated his life to help his fellow farmworkers. He told me that many workers have not had a raise in pay in 20 years. Web-site: www.ciw-online.org

DR. NATHANIEL BRANDEN Photographed at home in Los Angeles, California. Meeting with Dr. Branden was like meeting an "old friend that I hadn't yet met". After losing everything in 1986, three years later I began to rebuild my life. In addition to the counselling that I needed, I embarked on an intensive search to understand many issues in my life, including the major one of self-esteem. Dr. Branden's books were an important resource of information and help for me. After the shoot, he replied to one of my interview questions by asking me how I would answer the question myself. I informed him my answer might sound familiar – quoted directly from his books! Web-site: www.nathanielbranden.net

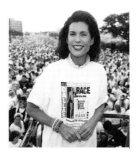

NANCY BRINKER Photographed in Dallas, Texas before a fund-raising march. My plan was to photograph Nancy from the top of a cherry-picker just before the race began. But, where was the cherry picker? We finally located it, and it made its way into position in front of the crowd. I had to lean so far back to get the shot, that somebody had to hold on to me to prevent me from falling out. Nancy is a warm gentle soul, with a great sense of humor. During our interview later, I asked Nancy, "How do you handle problems that are most daunting in life?" She paused for a moment, showed a little smile, and answered "Chocolate". Then she gave me her serious answer. Nancy never forgot the promise she had made to her sister, Susan, to help find a cure for breast cancer. Web-site: www.breastcancerinfo.com

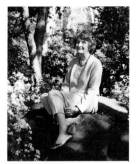

DR. HELEN CALDICOTT Photographed in Central Park, New York.
We strolled through the park looking for a suitable place to conduct the shoot. I chose my spot, just the right blend of rock, trees, and sunlight. Dr. Caldicott sat down, and as I was composing the picture, I noticed a raccoon about 40 feet away. It ran towards us, and headed into the trees. I was clenching my camera hoping that it would join Helen in the portrait. My prayers were answered when, it reappeared, climbed up the tree a few feet away from Dr. Caldicott, and stared into the lens!
Web-site: www.noradiation.org/caldicott

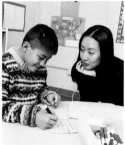

ANNIE CHAU Photographed in San Mateo, California.
I heard about Annie when she was featured on Oprah. The show featured how young people have given back to society. In my interview with Annie, her message to people was, "Try to make a difference." The children related so beautifully to her and were deep in concentration on their artwork as I photographed them.
Email: artspanorg@aol.com

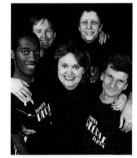

DIANE DUPUY Photographed at Famous PEOPLE Players in Toronto, Ontario.
Diane has created a troupe of performers who might otherwise be marginalized in society, and guided them to find purpose and fulfillment to the world of entertainment. She is both a feisty perfectionist and yet a sensitive and compassionate individual, who in my opinion, epitomizes the expression – 'the show must go on!' Web-site: www.fpp.org

DEANNA DURRETT Photographed at home in Louisville, Kentucky.
Some people as they mature through life in their forties and fifties find a path that they want to follow, a path with meaning and purpose. Deanna found hers when she was thirteen. While in a restaurant, she noticed a child attempting to buy cigarettes from a vending machine and her crusade to stamp out underage smoking has never abated. I was struck by her single-minded purpose. I asked her if she would like to be the first female President of the United States. She has not ruled it out.
Web-site: www.tobaccofreekids.org Email: deannad@kyaction.com

DR. WAYNE DYER Photographed in Lily Dale, New York.
I attended Dr. Dyer's workshop before photographing him. He reminded us that we are primarily spiritual beings living a human experience, not the other way around. His calm, strong and soothing voice hit a resonant chord in the attendees. My shoot and interview with him was shorter than expected because of the large number of people who lined up to have their books autographed. I was amazed by the number of unselfconscious men and women who waited to get a hug from Wayne.

ARUN GANDHI Photographed in Memphis, Tennessee.
Mr. Gandhi related a story of to me of when he lived with his grandfather for 18 months. As a thirteen year old, he came home from school one day, and along the way threw away a pencil that had only three inches left. His grandfather asked him why he threw away a perfectly good pencil, and sent him outside to find it. He taught him not to waste the world's precious resources. I found Arun to be a kind, down-to-earth, serious man.
Web-site: www.gandhiinstitute.org

URI GELLER Photographed at home in Sonning-On-Thames, England.
I arrived at Uri's house with my full complement of cameras and lights. In addition, I brought a solid spoon that was originally my grandmother's. Uri allowed me to photograph the whole process as he bent the spoon by focussing his energy, and lightly touching the spoon at the same time. Incredibly, it started to bend after two or three minutes. Uri handed it to me, and I watched it continue to bend while I held it. I then placed it on a table, and we watched as it bent some more. Uri is a high energy, passionate, and kind man. In addition, he is a painter and sculptor. Web-site: www.urigeller.com

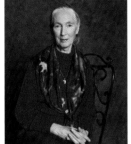

DR. JANE GOODALL Photographed in Toronto, Ontario.
I was hoping to photograph Jane in Gombe Park in Tanzania with a live chimpanzee, but our schedules did not mesh. I went to "Toys R Us", and purchased what I figured was the closest to a toy chimp hoping Dr. Goodall would agree to be photographed with it. To my amazement, I was informed that she travels with her own toy chimp, which she calls 'Mr. H.' I was thrilled when she agreed to pose with him. I found Jane to be both gentle and strong at the same time. Web-site: www.janegoodall.ca, www.janegoodall.org

JERRY GOODIS Photographed near Toronto, Ontario.
We were discussing doing the shoot in his home, when he informed me that he owned a Harley jacket, but no Harley-Davidson. Luck was on our side, when I discovered that a motorcycle show was on at a nearby convention center. I photographed Jerry on a Harley, and was delighted when a bald, muscled biker moved in and posed for my camera beside him. Email: jgoodis@attglobal.net

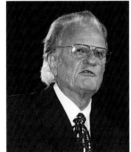

DR. BILLY GRAHAM Photographed at a crusade in Tampa, Florida.
I quipped to friends that I was probably the only Jewish person attending his crusade! Billy speaks with power, and conviction – it was an electrifying event. I also photographed Mrs. Graham before the crusade. Her enthusiasm and passion were apparent to all.
Web-site: www.billygraham.org

DR. JOHN GRAY Photographed in Mill Valley, California.
For every portrait that I do, I try to do something unique with the subject and/or environment. Dr. Gray made my job easy. His assistant, brought along flowers that he asked if he could hold during the shoot. He explained that in his healing seminars, he surrounds the stage with flowers. He feels that flowers absorb negativity that is present in the room. I felt that photographing a man holding flowers, was still rather unconventional, and would make an excellent portrait. I found John to be a gentle spiritual man, who is very much in touch with his inner power. Web-site: www.marsandvenus.org

MONTY HALL Photographed at home in Los Angeles, California.
Monty originally wanted to be a doctor, but he is proud that the millions of dollars that he has raised for numerous charities has aided more people than he could have as a physician. I found Monty to be an articulate, intelligent man who would have made a brilliant doctor if he would have gone that route. We sat in his office and watched the first episode of "Let's Make a Deal." Monty showed me one show where a participant made all the wrong guesses, and ended up with basically nothing. He told me with great pride that she still gave him a big hug!

RICK HANSEN Photographed in Vancouver at the University of British Columbia. Rick was asked by his young daughter some time ago, that if he could live life over, would he still take that ride in the truck which crashed, leaving him disabled. Rick replied incredibly, "Yes." He values the life that he has created for himself, and all of the lives that he has affected for the better. Rick is convinced in the next decade that the "wheelchair will be in a museum with the medical advances that are being made in spinal cord research". Web-site: www.rickhansen.org

JUDY HENSLEY AND THE (FORMER) GRADE 7 CLASS FROM WALLINS ELEMENTARY SCHOOL Photographed at Black Mountain, Kentucky.
Judy and her class were featured on Ted Koppel's "Nightline" for saving a mountain from strip mining. I was impressed by how an elementary school class from a poor region of Kentucky could affect such change in society. Judy is an exceptional teacher who gives from her heart as well as her head, to her students. I think of the following phrase when I reflect on Judy's success. "Anything the human mind can conceive and believe, it can achieve." Web-site: www.uky edu/communitycolleges/sou/wallinsschool.4thgrade.htm
Email: judithvictoria@kih.com

JULIA BUTTERFLY HILL Photographed 100 feet up in "Luna", in northern California. This is undoubtedly one of the most exciting shoots I have ever done. With a guide we climbed a mountain for 45 minutes, and then I was faced with a 100 foot rope. With no previous experience, I was strapped into a harness, and took about 20 minutes climbing the rope using a quickly learned mountain climbing technique. Although looking down was pretty scary, I tried to concentrate on the job at hand. I was cheerfully invited into Julia's tree house. Her passion and near evangelical zeal was mesmerizing. I knew that Julia would outlast the lumber company that wanted to fell the tree. She is a wonderful role model and reminds people to follow their dreams, and stand up for what they believe in. Web-site: www.circleoflifefoundation.org

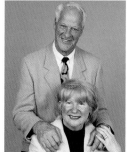

GORDIE AND COLLEEN HOWE Photographed in my studio in Toronto, Ontario.
What a powerful team! They are both superb role models: Gordie, a hockey icon and Colleen as a superb business manager. I had requested that they both pose with hockey sticks for the shoot. The sticks were not available, so I was pleased to do the shoot with a "thumbs up sign." Unknown to me, Del, their manager videotaped me photographing the Howes, giving me a pleasant surprise. Web-site: www.mrhockey.com

JAWDAT IBRAHIM Photographed in Abu Ghosh, Israel.
I discovered Jawdat featured on a front page *New York Times* article. It is refreshing, and admirable that a lottery winner chose to go back to his small village and help his people. Jawdat still has the same friends that he had in high school, in addition to making new ones. Jawdat was raised with principles, and he never forgot them. We conducted the interview in his beautiful restaurant where he showed me photographs of King Hussein, and other world leaders that he has met. Email: jawdat@jrol.com

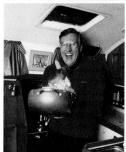

GRAHAM KERR Photographed on his boat in Washington state.
Graham exudes enthusiasm, excitement, and love. It is nearly like the boat I photographed him in couldn't contain him. Graham related to me with pride, the life-story of the Pacific Salmon. He is amazed at the journey of thousands of miles they make to come back to spawn. They swim upstream and travel through waterfalls. Having come back from adversity, he is a like a born-again human being. It is exciting to see someone embrace life so whole-heartedly. Web-site: www.grahamkerr.com

CRAIG KIELBURGER Photographed at home, near Toronto, Ontario.
Craig shared a story with me. While visiting in a third-world country, he had a long conversation with a street child. When, Craig had to go, the boy wanted to give him a present – but he had nothing to give. So, he took the shirt off his back, and gave it to Craig as his gift. In return, Craig gave him one of his shirts. Craig told me that the people he admires the most in the world are the street children, because of the way they support and help each other. Web-site: www.freethechildren.org

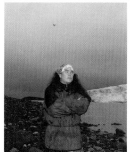

DUNE LANKARD Photographed in Cordova, Alaska.
It was like a supernatural experience. Dune was posing majestically looking off into the distance facing "Child's Glacier." There were no birds or wildlife anywhere during the 45 minute shoot. I mentioned that it would be great to get an eagle in the shot. Suddenly, we saw two small specks come over the horizon. They were two young eagles. I rapidly positioned myself to capture the image of one of the eagles flying over Dune's head. Web-site: www.redzone.org

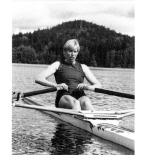

SILKEN LAUMANN Photographed near Victoria, British Columbia.
I know the power of the mind to heal the body, and the power of believing in yourself. It was an honor being in the presence of someone who defied all the odds, and the doctors' predictions, and went back to compete only ten weeks after a major leg injury before the 1992 Olympics. It was refreshing and inspiring for me to see someone not accept the negative predictions of many around her at the time and overcome the physical obstacles. Web-site: www.silkenlaumann.com

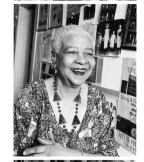

JENI LeGON Photographed at home in Vancouver, British Columbia.
Jeni is a woman in her eighties who has more energy and joy in her than most people I meet who are half her age. I was enthralled by her stories of when she was a young girl singing on the street for her neighbors. It is a pleasure seeing a resurgence of Jeni's career now as she flies all over the USA receiving awards. Jeni is a positive testament to the saying "we are only as young as we feel!" Email: jazz@oanet.com

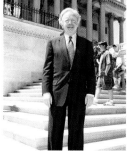

SENATOR JOSEPH LIEBERMAN
Photographed on the steps of the Capitol, Washington, DC.
I wanted to do something unique while taking the Senator's portrait. I got my wish when a group of students from Connecticut surrounded the Senator asking for his autograph. I admire someone who has the guts to speak his mind. Morals should come over party allegiance. I had the sense when I was with Senator Lieberman, that he keeps the bigger picture in mind when he makes decisions in Washington. He is determined to help make the world a better place. I look forward to following the Senator's escalating political career. Web-site: www.lieberman.senate.gov

ART LINKLETTER Photographed at home in Los Angeles, California.
Art is eternally young. He still downhill skiis, and he insisted that he still surfs, but only the smaller waves. He told me he agreed to be part of my book for two reasons: first, because I am Canadian, and second, he loves the topic of integrity. I was fascinated hearing Art talk about his friendship with Walt Disney and Norman Vincent Peale.

MAJOR GENERAL LEWIS MacKENZIE (RET.)
Photographed at home in Bracebridge, Ontario.
What struck me about Lewis MacKenzie, was that he is a straight shooting, suffer no fools, passionate military man. He has a good sense of humor which would have helped him relate to the men and women under his command. Lewis was originally going to be the dignitary associated with the campaign to ban landmines world-wide. He graciously stepped aside, when Princess Diana was brought on board.
Email: lewmack@muskoka.com

DR. PHILLIP McGRAW Photographed in Dallas, Texas.
I was originally going to photograph Dr. McGraw in his mock courtroom. I then asked him where he might like to be photographed. He told me he loved the mustang sculptures in town. I checked it out, and decided that it would be a perfect location. I saw that the passion and drive of the mustangs is similar to Phil's unrelenting drive.

NELSON MANDELA Photographed in Ottawa, Ontario.
I chatted briefly with Mr. Mandela in Prime Minister Chretien's office and I was impressed with his razor sharp mind, while at the same time his warm and kind disposition. I came across a phrase that seems to sum up his twenty-seven years in solitary. "All the darkness in the world cannot put out the light of a single candle."

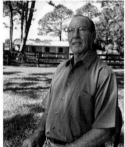

DR. EDGAR MITCHELL Photographed at home in Palm Beach County, Florida.
I had expected to photograph Dr. Mitchell surrounded by photographs inside his office. Here was the portion of the Bible brought back from the Moon, and many other interesting objects. But, I wanted something different. Every time I go on a shoot, I walk around the location working on creative ideas. I hit on it – have Edgar sitting in his backyard looking skyward. I saw the gleam in his eye as he remembered a time thirty years ago walking on the surface of the moon. I asked him what it felt like to walk on the moon. He replied it was like walking on a trampoline, while wearing the equivalent of four or five snowsuits.
Web-site: www.edmitchellapollo14.com

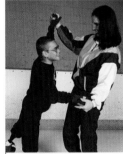

ELIZABETH O'DONNELL Photographed in Buffalo, New York.
Elizabeth has a loud, infectious laugh. She exudes love and passion. I was touched to see children skating with walkers, with prosthesis, and limited vision. She shared her beliefs that as children excel in a sport, it helps them to develop their self-esteem. Elizabeth would like to be remembered "for having a talent, and helping people with that talent."
Web-site: www.sabahinc.org

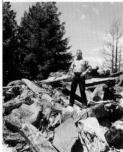

MICHAEL O'NEAL Photographed in Stafford, California.
His passion for the environment is interlinked with his drive to see justice done in the lawsuit he was involved in. What struck me about Michael was his sheer determination. It is not everyone who will take on a large corporate entity. I felt all along that he would triumph in court. Email: mntmike@juno.com

114

DR. NANCY OLIVIERI Photographed in Toronto, Ontario.
It is a nearly a superhuman task to fight deception and indifference. Dr. Olivieri made a decision to not be silenced by the drug company, university and hospital at great personal risk to her position. Society needs more people who will go against all odds and do what they feel is just and right. Nancy has just received an award from the Washington-based Civil Justice Foundation for "performing an extraordinary deed for consumer safety." Web-site: www.doctorsintegrity.com

SHIMON PERES Photographed in Tel Aviv, Israel.
Mr. Peres has a deep longing for peace, and believes there will eventually be peace between Israel and its Arab neighbours. He speaks eloquently of the day when the Middle East will not be racked by war and strife. I was impressed by his deep conviction that the warring parties will one day achieve great economic success once the obstacles are overcome. Mr. Peres' personal courage, and his moderating influence is very important in the delicate negotiations in the Middle East. As a strong supporter of Israel, I found it a great honour to meet Shimon Peres.

KIM PHUC Photographed in Toronto, Ontario.
It is nearly impossible to imagine the pain that Kim went through as a child, which still occasionally haunts her even today. Kim showed me her back which had been badly scarred by the napalm. Kim is a woman bursting with love and hope for humanity. She stands as a beacon of light for forgiveness, and hope for the future.

BONNIE RAITT Photographed in Mill Valley, California.
Bonnie became an integral part of the portrait session giving her suggestions from her years of being photographed. I quipped that I would be pleased to hire her if she ever gave up her day job. The same vitality that Bonnie expresses in her music, comes across in conversation with her. I found her to be a very warm person.

NORBERT REINHART Photographed in Collingwood, Ontario.
There are not many bosses out there in the world, who would do what Norbert did. He told me that he had a rifle pointed at him 24 hours a day. He tried once to escape, and after that attempt he was tied with a rope to a tree. To simulate the isolation that he felt being held hostage in Columbia, I photographed him in a cave in Collingwood, Ontario.

JOHN ROBBINS Photographed at home in Santa Cruz, California.
John is living the life that he always dreamed. He gave up the possibility of great wealth by decideing not to work in the family ice-cream business. John told me his mission in life "was not to develop a 32nd flavor of ice-cream!" John has dedicated his life's work to improving humanity through his books and his teachings.
Web-site: www.foodrevolution.org

CHRIS ROBERTSON Photographed in Bracebridge, Ontario.
I also photographed Chris north of Fort Nelson, British Columbia. Driving up the very steep gravel mountain road, I couldn't even imagine driving a bike there, but Chris persevered and made it. Equally amazing was his ability to show up at any school or hospital along the way to inspire and cheer up all that he met. Chris nurtures that spark we all have to step out of formation, to go our own way and achieve something in the world. Web-site: www.chrisrobertson.com

DR. ROBERT SCHULLER
Photographed at the Crystal Cathedral in Garden Grove, California.
As a Jew, I have been asked why I watch the TV show "The Hour of Power" which features the evangelist Dr. Robert Schuller. I reply that in the second half of the show, Dr. Schuller gives a sermon (not unlike what I hear in synagogue) on "Possibility Thinking." The potential to strive and make a better world for yourself and others transcends all religions. Dr. Schuller is a positive force in the world.
Web-site: www.crystalcathedral.org

ALAN ROY SCOTT Photographed at home in Los Angeles, California.
Alan is a talented musician and song-writer, but he spends his time bringing musicians together from many different countries. When he was making arrangements to have a concert in Cuba, he was concerned that he was under surveillance as the U.S. does not have relations with Cuba. It was all in a day's work. The love of music is a uniting force that knows no boundaries.
Web-site: www.unisong.commbridge; www.musicbridges.com

MARTIN SHEEN
Photographed in Los Angeles, California, on the set of "The West Wing".
I asked Martin if he would consider being handcuffed for the shoot, as he has been arrested over 60 times as a social protestor. He said, "Sure, but give me the key first!" After the shoot, we visited the set of "The West Wing" where Martin suggested a great idea for a shot, and he proceeded to take off his shoes and socks, then sat on the presidential desk!

DUNCAN SHEIK Photographed at home in New York City, New York.
I found Duncan to be a gentle, spiritual soul. His loft studio was impressive with its recording studio, dozens of guitars, and the quiet peaceful area where he prays. After the shoot, Duncan played a song for me. I felt honored. Web-site: www.duncansheik.com

DR. JEFFREY WIGAND Photographed in Charleston, South Carolina.
A man who has the courage to take on a giant tobacco company, must very carefully weigh his options in life. He related to me the terror of having bomb threats telephoned to the school where his children were attending, because of his courageous stance. I felt it appropriate to photograph Dr. Wigand "walking in the waves." He told me that he tries to get down to the ocean on a daily basis.
Web-site: www.jeffreywigand.com

SPECIAL THANKS

I thank family, friends and associates for their support – some go back many years.

Howard Aster, Chaya and Avrum Birenbaum, Jerry Borins, Debbie Bauer,

BNI Bay St. Chapter, Sharon Brooker, Kate Burke, Robert Bodrog, Patricia Wismayer-Bucks,

Aidan Bucks, Paul and Michelle Buer, Donald Barr, Jeffrey Brown,

Bill and Gladys Byers, Jackie Couch, Craig Cowan, Brenda Cooke, Ron Csillag,

Claudia Carvaggio, Castleview-Wychwood Towers Coffeehouse Volunteers,

CAPS – Hamilton and Toronto Chapters, Jacque David, Larry Diachun, Burt Dubin, Cathy Dusome,

Stan Dermer, Vern Farrell, Bonnie Francis, Dwight Fowler, Jerry and Elena Goldblatt,

Raella and Harold Goldblatt, Barry Gang, Paul Grof, Laura Goldstein, Michael Greene, Norma Gibbs,

Yvonne Giroux, Al and Anne Hersh and family, Mabel Hanson, Marilyn Hall, Andrew Hall, John Hardy,

Barb and Josh Israel and family, Maya Irvine, Eric Jonasson, Mary Jowett, Ruth Kaplan,

Kathy Kawasaki, James Klotz, Joe Kronick, Paul and Teresa Longo, Phil Lapidus, Janet Nish-Lapidus,

Graham Linton, Anne Ledden, Eleanor Levine, Susan Lewis, Tim Lipson, Bill Lawrence,

Mel Lastman, Gayle Goldberg-Marcus, Cathy Merigliano, Jim McConvey, Bob Myran,

Alex Neumann, Mary Nolan, Lois Page, Julia Poger, Barb Stalbecker-Pountney,

Bonnie Pascal, John Pollock, Jim and Carolyn Parsons, Barry Philp,

Bert Raphael, Mini Ross, Rochelle Gai Rodney, Boaz Rotaro, Sandy Rakowski

Janice Raymer, Morton and Bracha Rappaport and family, Wayne Roberts,

Elizabeth Siegfried, Kathy Glover-Scott, Barbara Shainbaum, Fred and Laura Shainbaum

Lottie Shainbaum, Michael Skobac, June Struthers, Jonathan and Lydia Sheinbaum, Paul Saltzman,

Mair and Helen Saraga, Wendy Scolnick, Narelle Sitzer, Larry Schnurr, Albert Silver, Edith Silver,

Bob Sealy, Ellen Taube, Toronto CAPIC board members, Vicki Vancas, Joel Walker, Carolyn Young.

Technical Details

Photographed on Kodak Portra film, 160 and 400 ISO
120 and 35 mm.

Camera equipment: Mamiya 645, Canon A2